Social-Documentary Photography in the USA

Social-Documentary Photography in the USA

R. J. Doherty

P 70

AMPHOTO
American Photographic Book Publishing Co., Inc.
Garden City, New York

fH

Copyright © 1976 by American Photographic Book
Publishing Co., Inc. for text of English edition

Social-Documentary Photography in the USA
is part of a series entitled
PHOTOGRAPHY: MEN AND MOVEMENTS
Edited by Romeo E. Martinez in cooperation with Max A. Wyss

Copyright © 1974 by Verlag C. J. Bucher,
Luzern und Frankfurt/M for German edition

Published in Garden City, New York, by American
Photographic Book Publishing Co., Inc. All rights reserved. No
part of this book may be reproduced in any manner
whatsoever without the written consent of the publisher.

Library of Congress Catalog Card Number 75-34604
ISBN 0-8174-0316-7

English translation: Fritz Oberli
Photographs printed by C. J. Bucher, Luzern/Switzerland
Text printed in the United States of America

PREFACE

The photographs appearing in this book were selected to show a wide range in the works of the three projects represented. The works of Jacob Riis, Lewis Hine, and the FSA (Farm Security Administration) all evoke some very familiar pictorial symbols. The pictures that stand for these three monuments of photography are those familiar ones which tend to identify the projects, but may, in fact, distort the real meaning of these three works. Another book of the same symbolic pictures from these three projects would serve little purpose. This is not to deny the importance of the pictures, because they have reached the pinnacle of a symbol through their excellence. "Bandit's Roost," Illustration A, by Riis is one of the most well known images in the history of photography, because it symbolizes the photographer's social concern. Even to the social worker, it emphasizes the power of photography as a communicative tool. Illustration B by Riis is what it's all about: immigrant poor living in substandard housing. Illustration C by Hine continues the tale of the abuse of children who keep coming to the American shores in the belief that it is better here than there, Illustration D. Thousands of people arrived in America

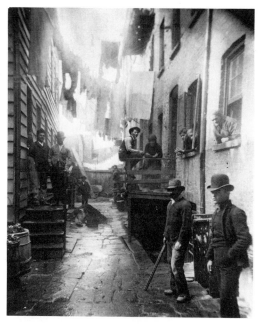

A. Jacob Riis. Bandit's Roost, n.d. (no. 101)

B. Jacob Riis. Italian mother and her baby in Jersey street, n.d. (no. 157)

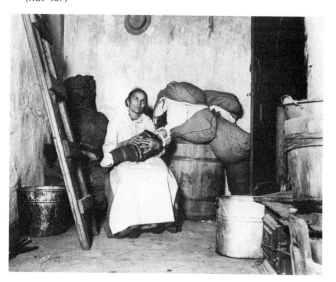

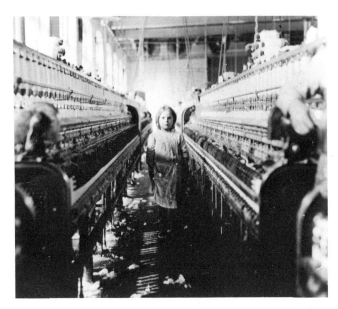

C. Lewis Hine. Ten-year-old spinner in a North Carolina cotton mill, 1909. (IMP no. 2508)

D. Lewis Hine. Italian family seeking lost baggage, Ellis Island, 1905. (IMP no. 3982)

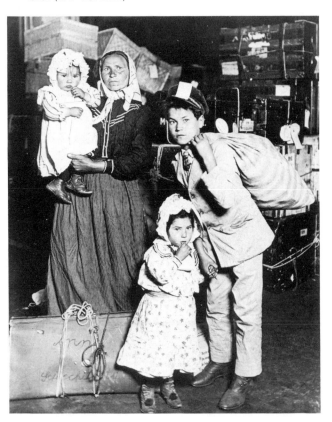

each year in search of a better life than they were living in Central or Eastern Europe. In addition, the Chinese, never granted the same privileges as their "white" counterparts, flocked to this country. If the life portrayed by Riis and Hine at the turn of the century was "better," it staggers the imagination to comprehend what these people left behind. Twenty-five years later, mothers and children are still the victims of inadequate housing, Illustration E, and the families of the nation are little better off than their ancestors were in Central or Eastern Europe, Illustrations F and G.

There is a ray of optimism in all of this work, because each generation of immigrants gave way to the next, moving up to a slightly higher level on the economic scale. To be sure, the bottom of the scale has never wanted for victims, and when one group moved "up," there was another to fill the gap below. Currently, the Puerto Ricans and the southern blacks are in the corresponding position of the Italians and Jews at the turn of the century. The optimism comes from the fact that Riis did accomplish some of his goals. Mulberry Bend, long notorious as a den of thieves and all that was evil in a large metropolitan

city, was torn down and a park was made. Schools were added and educational programs were opened to provide opportunities as a result of Riis's efforts.

Child labor laws were enacted, labor unions rose to defend and protect the sweatshop workers, and Paul Kellog's *Sur-*

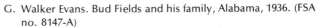

F. Arthur Rothstein. Cimarron County, Oklahoma, 1936. (FSA [RA] no. 4052-E)

E. Dorothea Lange. Migrant Mother and children, California, 1936. (FSA no. 9058)

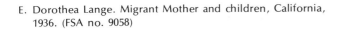

G. Walker Evans. Bud Fields and his family, Alabama, 1936. (FSA no. 8147-A)

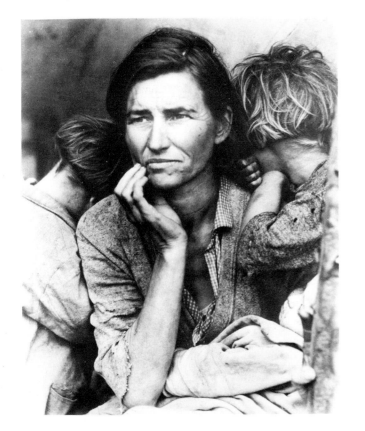

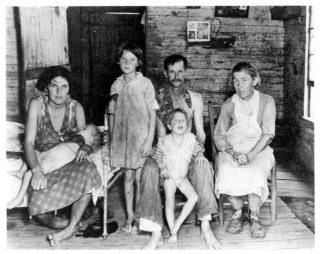

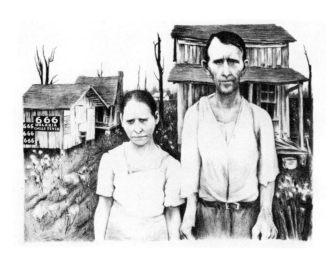

H. Ben Shahn. Lithograph from photograph, no. 2. See
 Illustration no. 61.

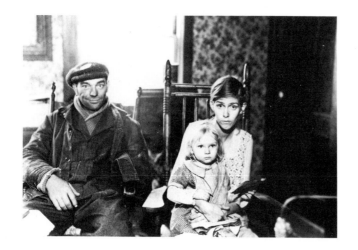

vey Graphic carried the torch of Hine and later Stryker's FSA. The Dust Bowl was stopped, and for a brief period in our history, the small farmer had a bright ray of hope that government was on his side against the "BIG MAN."

The symbol of this hope is best expressed in the picture of Riis, showing the little girl "Sweeping Back the Ocean," Illustration 11. One almost believes that she could, in light of the fact that these three photographic projects did change the face of America. To some degree, they also changed the face of Photography.

J. Paul Carter. Family in Albany County, New York, being
 relocated for the construction of a military camp, 1936. (FSA
 [RA] no. 2841-B)

Social-Documentary Photography in the USA

The title of this book needs some definition, particularly for the historian. The word documentary, as applied to photography, does not appear before the mid 1930's. The photographers of the Farm Security Administration (FSA) appear to be the first to be called documentary photographers, and the description of a documentary photographer is best explained in the words of Roy E. Stryker who was Director of the FSA project. "The main difference between the man who is miscalled the pictorialist and the man who is misnamed the documentarian is this: what to the first is either a way to embellish or a purpose sufficient in itself, to the other becomes a means to an end . . ." Stryker goes on to say, "Would not a great stride in understanding and valuation be made if we substituted the historic names for the purely photographic ones? Would it be too much to suggest that 'pictorial photography' be named 'realist photography'?" To further modify documentary, prefaced by social, is to suggest that the subject matter of this book deals with the social aspects of the times represented by the works of the three "realists" who are represented here.

"Documentary" photography has often been called "ash can photography," in the sense that it has always shown the seamy side of life. To quote Stryker again, " 'Documentary' is an . . . affirmation, not a negation. Certainly, the documentary photographer is a realist rather than an escapist . . ."

Riis, Hine, and Stryker were not the first to realize the potential of the photograph for social commentary. The publishers of the reprint of *Street Life in London* by Smith and Thompson, Benjamin Blom & Co., note that "In John Thompson's hands, the camera first showed its potential as a vehicle for social comment." While social-documentary photography flowered in America, the beginnings appear to be in England in 1877. Three names stand out in the history of photography as part of a social crusade—Jacob Riis, Lewis Hine, and FSA. The last, while not an individual name, does have a name attached to it, Roy E. Stryker. Because the FSA was not the work of a single person, Stryker is less well known, but the work is an equally or better known body of work than that of the other two.

This book is not an attempt to equate these three works, for on the surface that would be impossible. The surviving work of Riis numbers about 425 negatives. The work

of Hine is variously estimated at between 6,000 and 9,000 images, and the files of the Farm Security Administration (FSA) at the Library of Congress in Washington contain a minimum of 130,000 pictorial documents and have been quoted by some authorities to contain as many as 270,000.

With this great difference in the three crusading works associated here, one might ask, Why are they brought together in a single volume? The most obvious answer is the common ground shared by the three. The three efforts attempted to move men's minds in the pursuit of a cause by appealing to their social conscience. Curiously enough, there is also a tenuous link between the three individuals, which forms a bond between them. The three men were much too individualistic to suggest that there was any continuity from the first to the last, but each respected the work of his predecessor. In the Riis Collection at the Museum of the City of New York, there are actually copy negatives of some of Hine's work, which Riis used for his propagandistic purposes. It is possible that some of the Riis-attributed pictures were actually the work of Hine. This is not to indicate that Riis was plagiarizing, but simply to indicate what Riis thought of Hine's work. The overlapping of these two personalities, both in time, cause, and the use of the photographic medium, has left an indelible mark on the effective use of photography as propaganda.

The next step in the link between the work of the three was one that lasted from 1925 until the death of Lewis Hine in 1940. In 1925, Roy Stryker collaborated with Tugwell and Munroe in the writing of *American Economic Thought*. This was the first substantial economics textbook that was illustrated extensively with photographs. Of the 225 photographs in this book, 70 are by Lewis Hine, Stryker being responsible for their selection. Lewis Hine's approach to documentary photography made a vivid impression on Roy Stryker. Although Stryker would shy at the use of the word propaganda, it is clear that he began to understand its potential in the twenties and then devoted the remainder of his life to practicing the art of its use.

Frequently, when the subject of social conscience is discussed, the label of propaganda quickly follows as the socially concerned advocate attempts to present his findings of injustice. At one time or an-

other, all of these photographs have been labeled propaganda, and in fact, they are. Propaganda is always a dirty word when it represents an idea or an action to which one is opposed. Roy Stryker was very sensitive about this word and avoided even talking about it, as though to deny its existence.

All three of these men, Riis, Hine, and Stryker, were clearly involved with the concept of propaganda in its most sophisticated form. They were trying to communicate and persuade a group of people to action: to believe in their cause and to take some action to correct what they believed was a social injustice. With the coming of World War II, the general public became more aware of the evils of propaganda than ever before. It is obvious that propaganda has an evil function as well as good, but no effort should be condemned because some choose to label it propaganda. Glenway Wescott, in speaking of the FSA, commented that ". . . for me this is better propaganda than it would be if it were not aesthetically enjoyable. It is because I enjoy looking that I go on looking until the pity and the shame are impressed upon me unforgettably." While Wescott's comment was

directed at the FSA project, it seems equally applicable to the works of all three men.

Of the three men studied here, only Hine was actually to become a photographer by trade. Jacob Riis (1849–1914) was a journalist. Lewis Hine (1874–1940) was a school teacher, and Roy Stryker (b. 1893) taught economics at Columbia University. More specifically, Riis was a police reporter for the *New York Tribune* and the Associated Press. Riis's exposure to the seamy and sordid side of New York during his early career in journalism led him to a compassionate avocation as a social reformer. So dedicated was his effort and of such impact in the city of New York, that to this day, a settlement house bearing his name stands, and during the past half century or more, Riis's name is more likely to be known among social workers than any other single group in contemporary America.

By today's standards, Riis was no flaming liberal. As a matter of fact, the contemporary liberal would be shocked by his christian, nordic white superiority. Riis questioned the potential merits of the Jews, the Italians, and particularly the Chinese. Riis stated that the pagan, mercenary "Chinaman" was "without the essential qualities

for appreciating the gentle teachings of a faith whose motive and unselfish spirit are alike beyond his grasp." Despite Riis's prejudices, which seem to have been held by many of his contemporaries, Riis was quite compassionate and felt deeply for the fate of his fellow man. He sensed a brotherhood deeper than his own ability to understand, and his efforts at social reform were not limited by his lack of insight into the peculiarities of different ethnic groups. Riis arrived in America in the spring of 1870 as an immigrant from Denmark. Spending but a short time in New York upon his arrival, he soon went off to the heavy industrial area around Pittsburgh. Returning a short while later to New York City, Riis began his contacts with Mulberry Bend, the police stations, the tramps, the unemployed, and the hunger facing the immigrant in this harsh and uncaring city. In his early contacts with New York, he was rebuffed and sought refuge for survival outside the city. Ultimately, Riis came back to New York with a devotion and a concern for the city that was to change Riis and New York. In 1877, at the age of twenty-seven, he became a newspaper reporter. Riis had one cause, and that was to improve the lot in life of those less fortunate than himself. In order to accomplish his goal, he had to expose, in its most vivid form, the life he sought to alter. Probably because of the difficulties Riis overcame as an immigrant, he was sensitive to the pain and anguish of the poor. Riis was overwhelmed by a desire to correct some of the obvious wrongs, and his position as a newspaper reporter provided him with the forum in which to carry on his crusade. He wrote many articles describing the conditions of the Lower East Side of New York, but nothing happened. Quickly, he realized that the written word had limits in its power to persuade. Riis hired photographers to assist him in realistic documentation of his subjects, but the slum areas were too frightful, and Riis's plans were too hazardous for the photographer. Riis finally realized that he would only succeed if he learned photography himself.

In *The Making of an American*, Riis stated, ". . . I had better explain how I came to take up photographing as a—no, not exactly as a pastime. It was never that with me. I had a use for it, and beyond that I never went." He purchased the apparatus, learned the technique of flash photography, and with considerable risk of life and

limb, he set out to record the evils of the slums of New York. The peril lay in the fact that those in the unsavory side of the slums wished to remain anonymous, and Riis was invading their privacy.

Lewis Wickes Hine was a school teacher from Wisconsin, who came to New York City in 1901. He was born in Wisconsin in 1874 and died in New York in 1940. Hine's earliest activity in New York was as a teacher in the Ethical Culture School. As early as 1908, he wrote an article published in *The Photographic Times* on photography in the schools, in which he advocated the use of the camera as a learning device. Many of the photographs illustrating this article were taken by his students. It is clear in Hine's writing that the aesthetic values were of the highest level of concern, and this one point of emphasis is the element that made him different from Riis as an individual and the FSA as a project. In a further article in *The Photographic Times* in August 1908, Hine said, ". . . in the last analysis, good photography is a question of art." Although Walker Evans, Ben Shahn, and Dorothea Lange were committed to the highest level of aesthetic consideration in their work for the FSA, art or aesthetics was relegated to a low order of concern on the administrative level. Rexford Tugwell, Director of the FSA, once emphasized, "that the photographs may be considered art is complimentary, but that is incidental to their purpose." Stryker himself has always been defensive about anyone referring to him as an "artist." Perhaps the reason that a single body of work by Hine reflects his commitment to high aesthetic standards is because he was an artist.

As a body of work, the FSA project doesn't maintain the same high aesthetic standards as that of Hine; however, if one singles out the work of a single individual, such as Evans, one can see his personal uncompromising commitment to art. The work of Riis should be considered here, because he is looked upon currently as an artist in addition to his role as a social reformer. Placing Riis alongside of Hine or Thompson, one can readily see that Riis possessed great native aesthetic ability, but it is also clear that the photograph was a tool in the pursuit of his primary concern, which was social reform. While all three projects aimed at reform, using photography to aid in accomplishing their goals, only Hine's of the three maintains un-

equivocally the same high aesthetic standards, because Hine was the only one who appears to have been committed to art first, with his art then being devoted to another objective. It would be fair to say that Hine was first an artist, but while this may seem to some to be a high level of achievement, it has many of the aspects of a derogatory term to others. Judith Mara Gutman points out that when job recommendations were made regarding Hine, it was stated that he was a "true artistic type" and "requires handling as such." Although Hine was a dedicated artist, his art was a tool with a lofty goal. Hine in his very early days commented that "I wanted to show the things that had to be corrected; I wanted to show the things that had to be appreciated."

One other curious distinction about Hine is that his immense personal productivity spread over a much longer period of time than did that of any of the other individuals involved in the FSA or the work of Riis. Hine's work toward the end of his career, such as the photographs of the building of the Empire State Building, Illustrations 40, 41, 42, and 43, is equal to that of any other period of his productive life. John Szarkowski identifies Walker Evans's most pro-

ductive period as that period of about 18 months wherein he was working with the FSA. For reasons unknown, the great periods of the great photographers seldom last as long as did the highly productive career of Hine. There were many periods of ups and downs for Hine, and his long career was not without anguish. Hine worked well through the thirties on many different projects, but many of them were spaced far apart, and the interludes were those of near poverty. During this period, Hine appealed many times to Stryker for assistance in the form of work, but Stryker seemed to be "stringing him along" with half promises that a day was coming. The day never came, because Stryker felt the demands of Hine were too much to deal with. Stryker did, however, try to interest several parties in aiding Hine through acquiring his work. One such attempt was a letter by Stryker to Archibald MacLeish, then Librarian of Congress, in 1939, suggesting that the Library of Congress acquire the Hine work as part of a giant national archive. The Library of Congress did not acquire the Hine work. Several years after the death of Hine, the Photo League of New York gave the Hine Collection to the

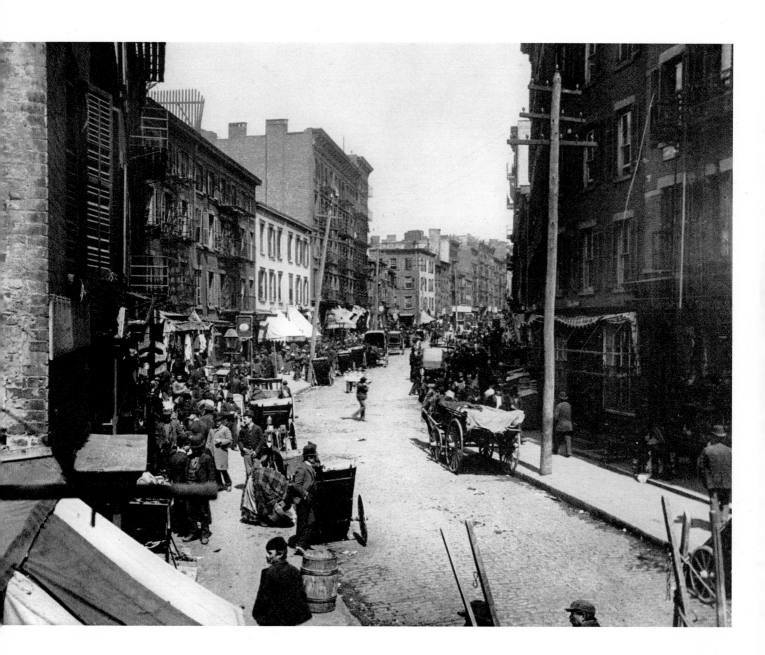

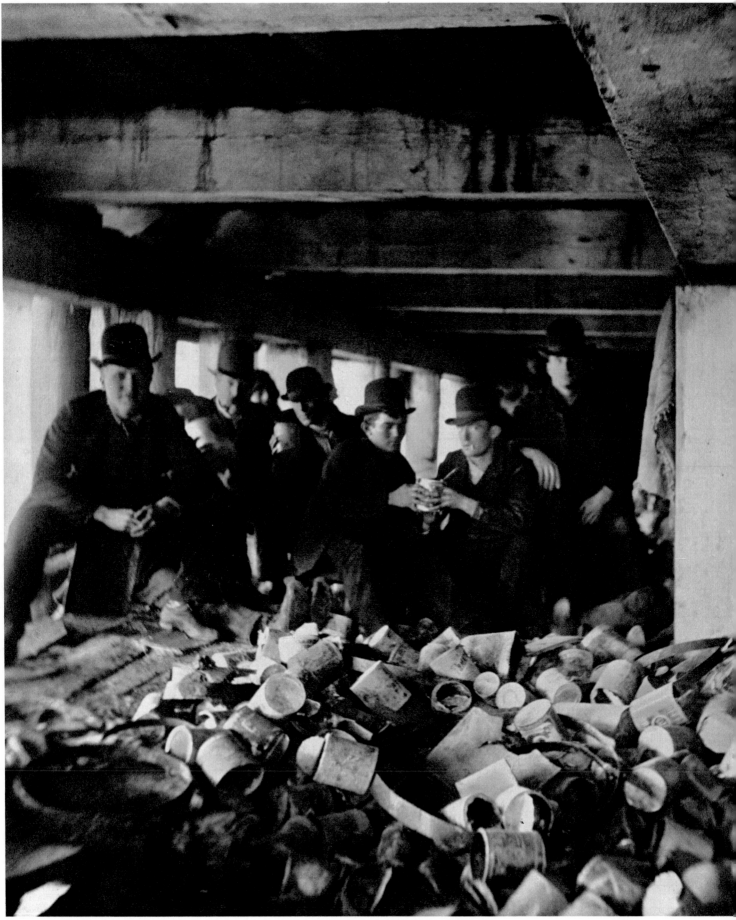

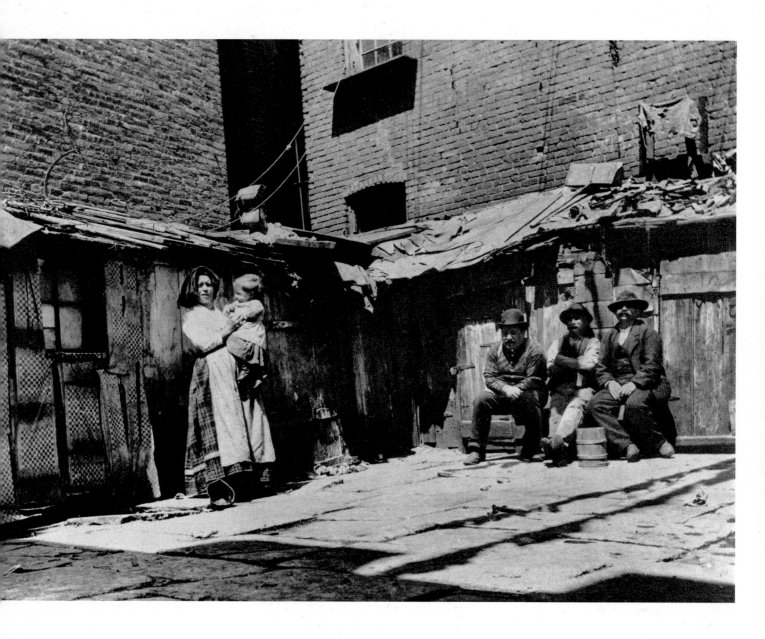

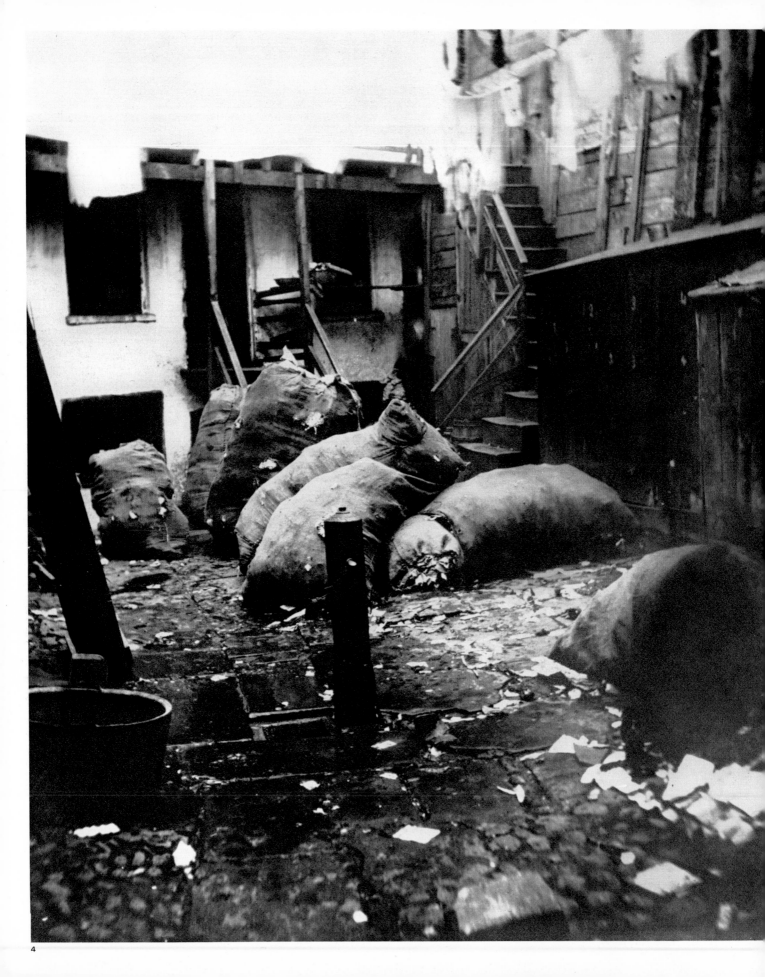

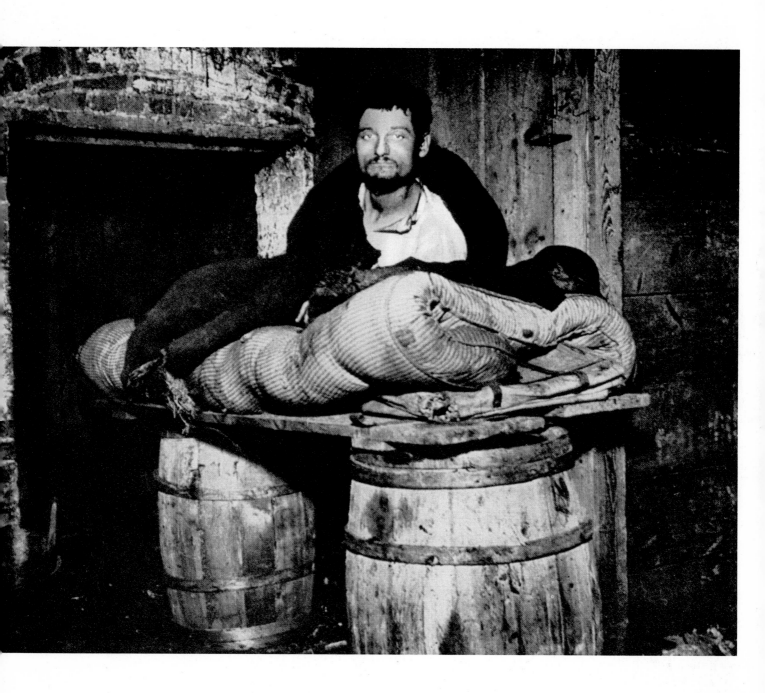

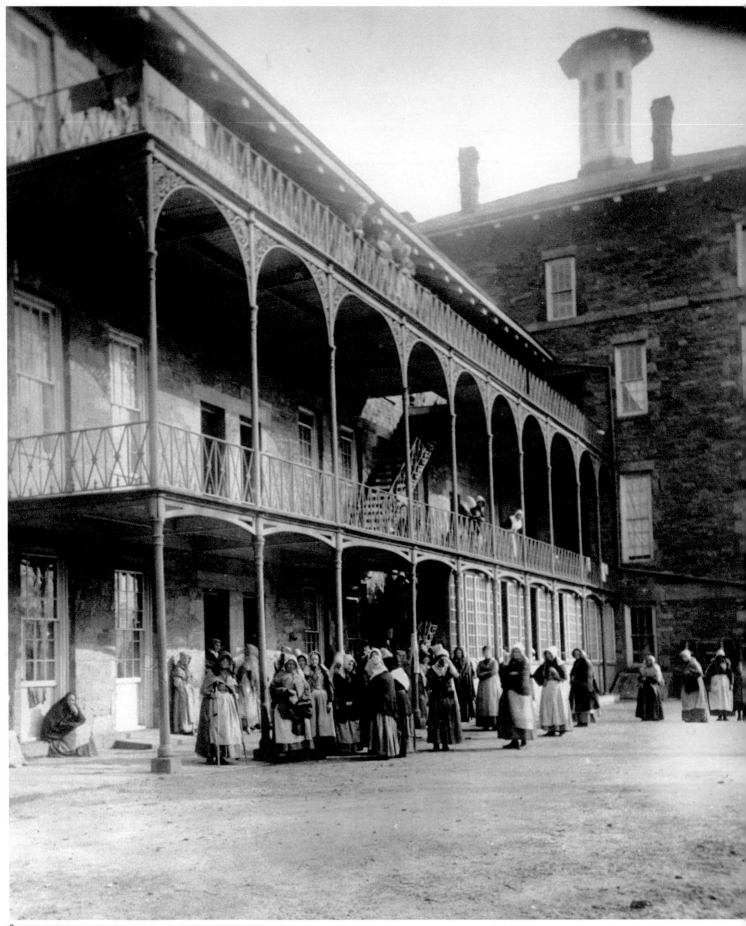

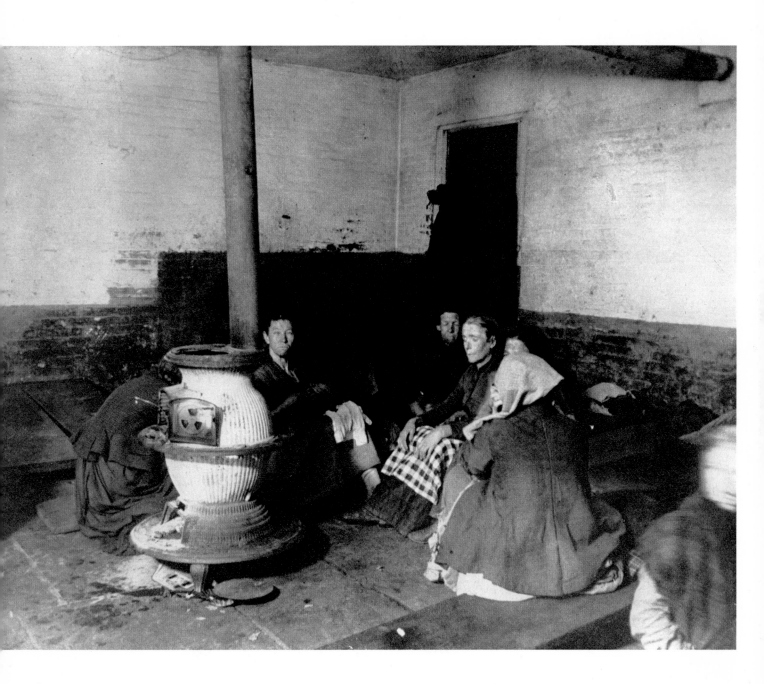

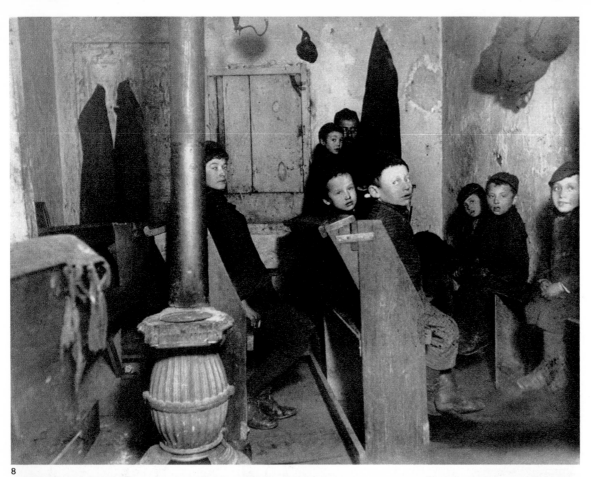

8

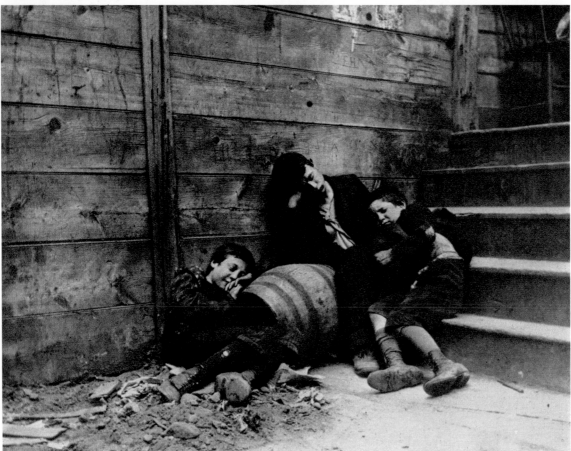

9

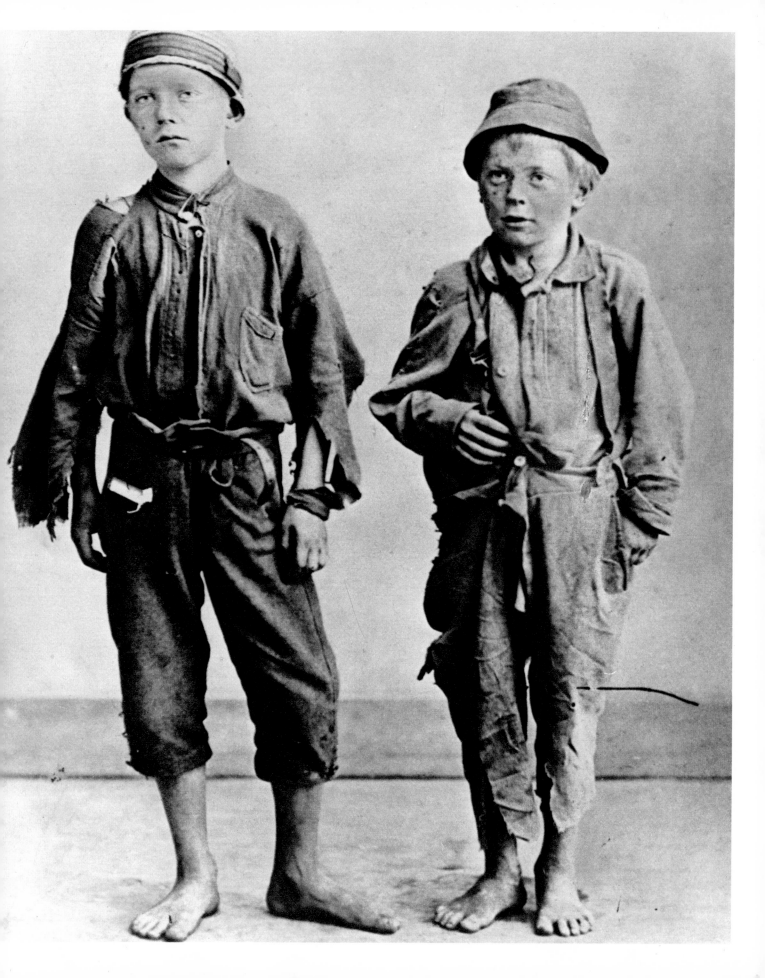

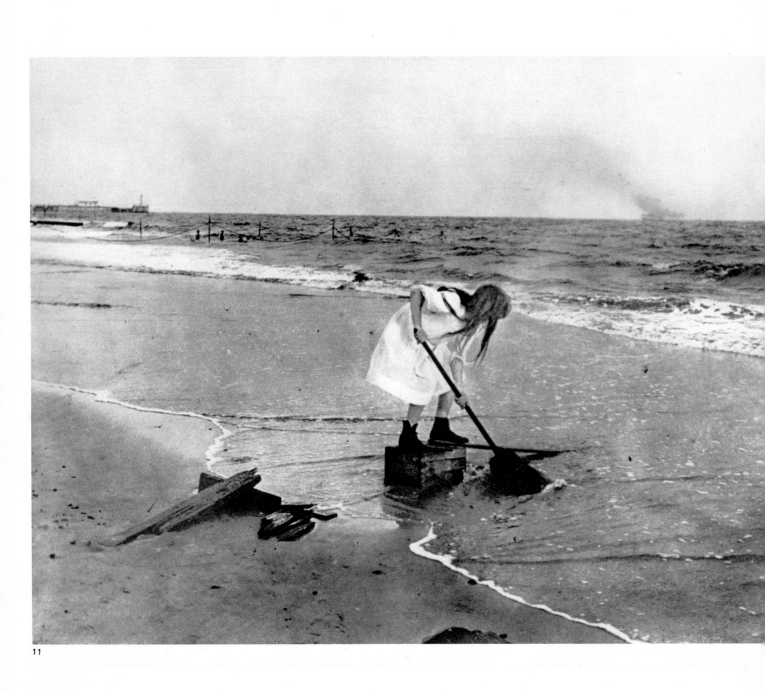

11

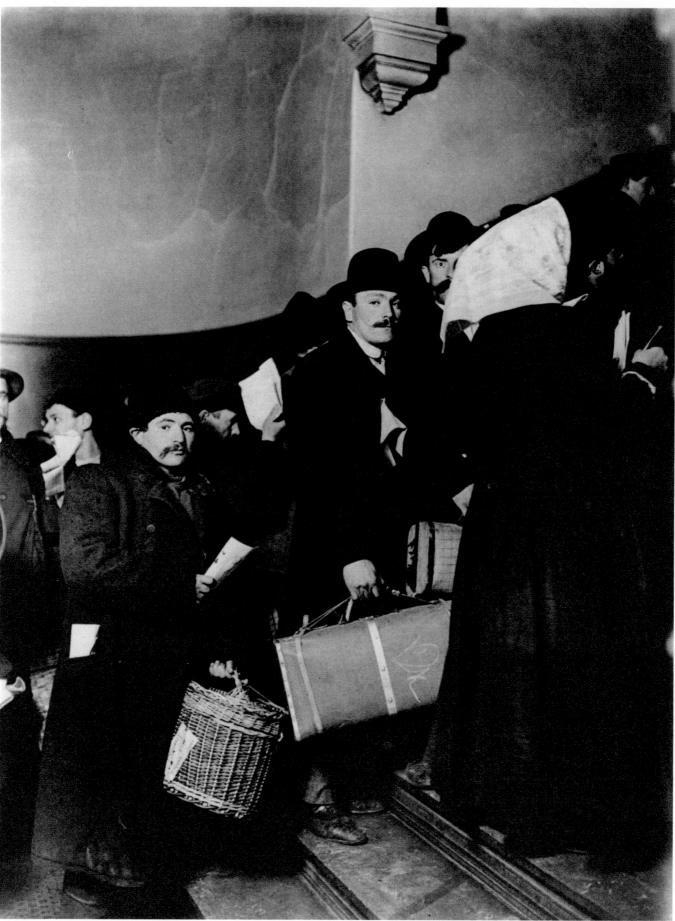

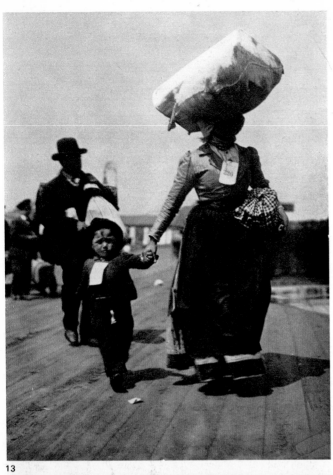

13

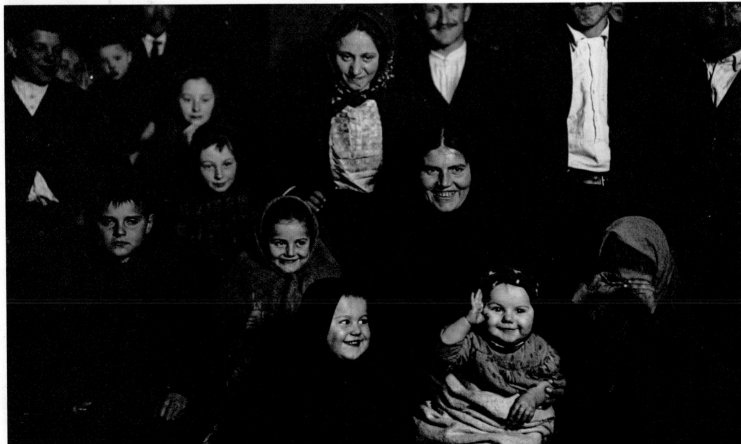

14

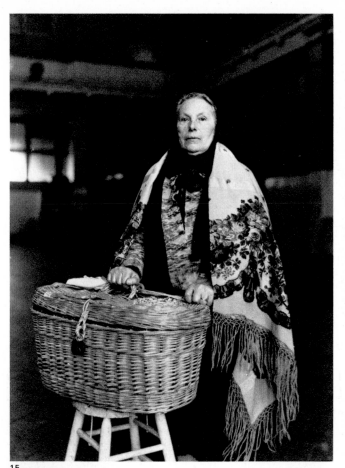

15

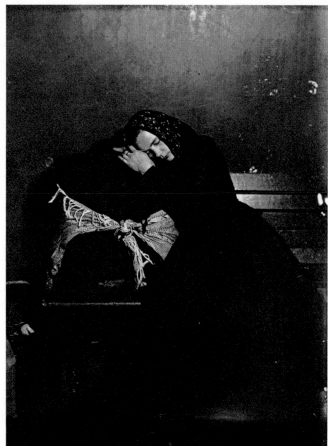

16

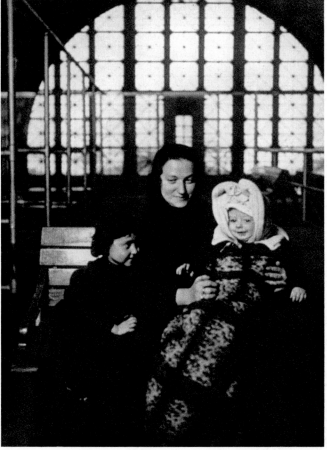

17

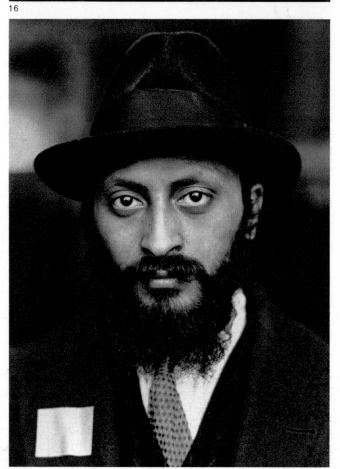

18

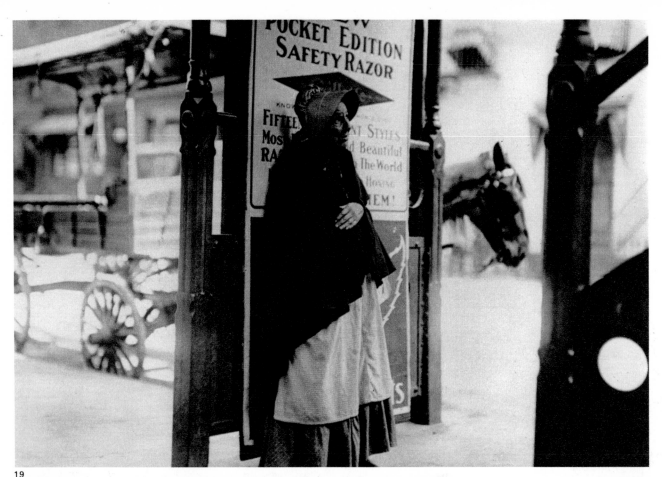

19

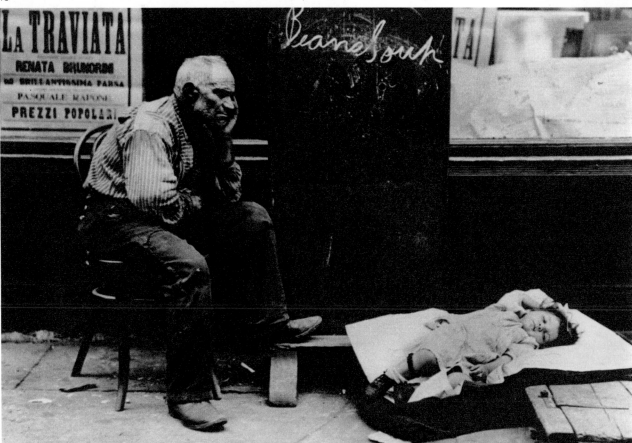

20

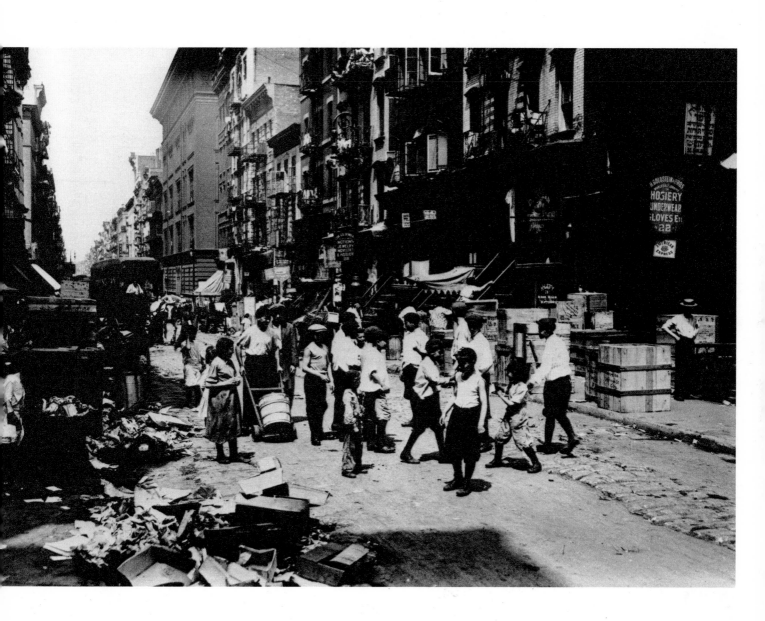

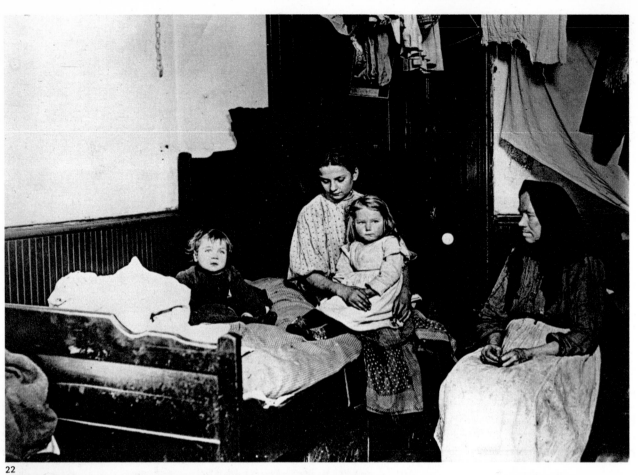

22

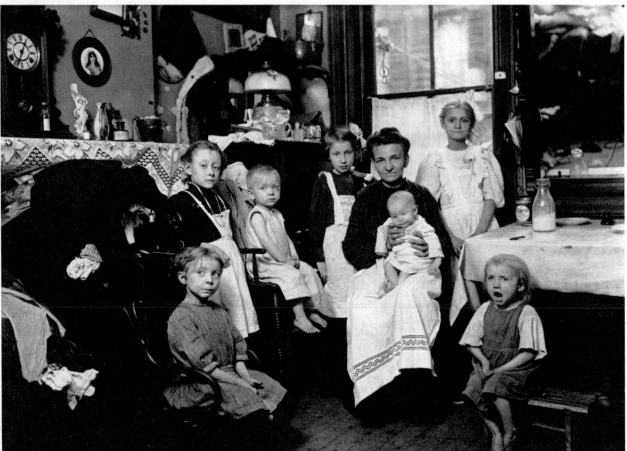

23

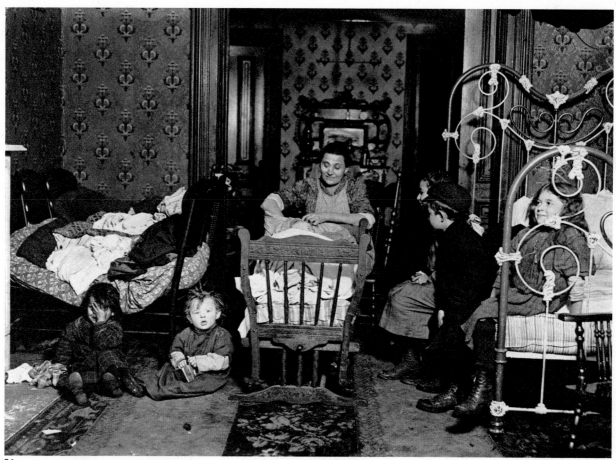

24

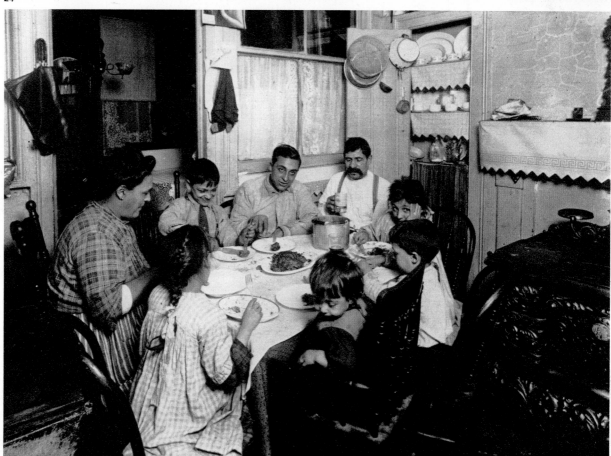

25

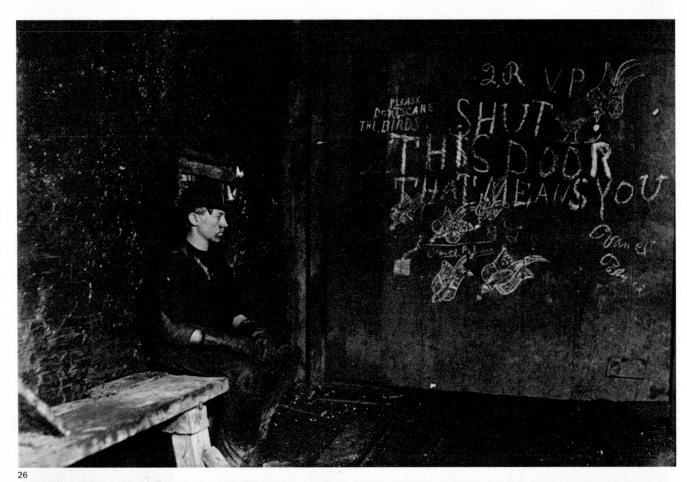

26

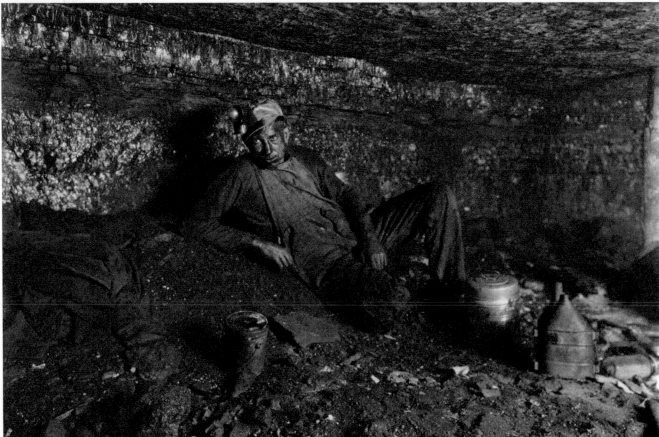

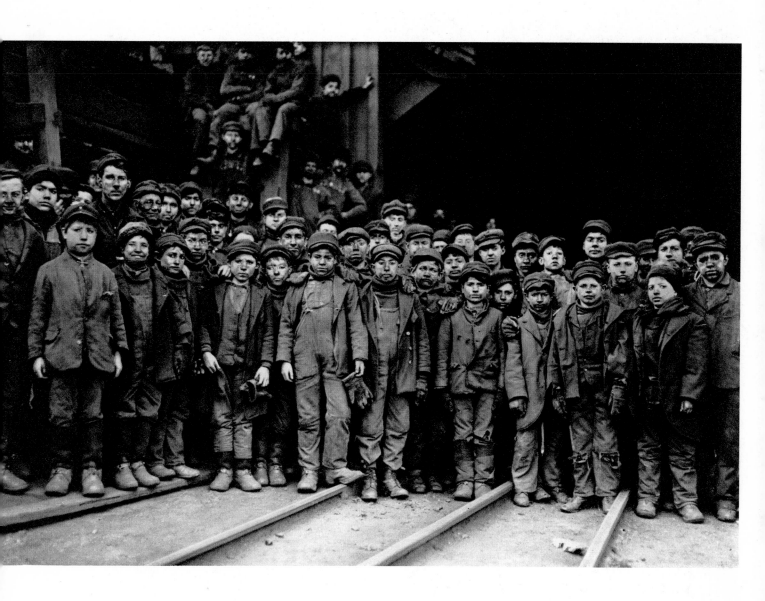

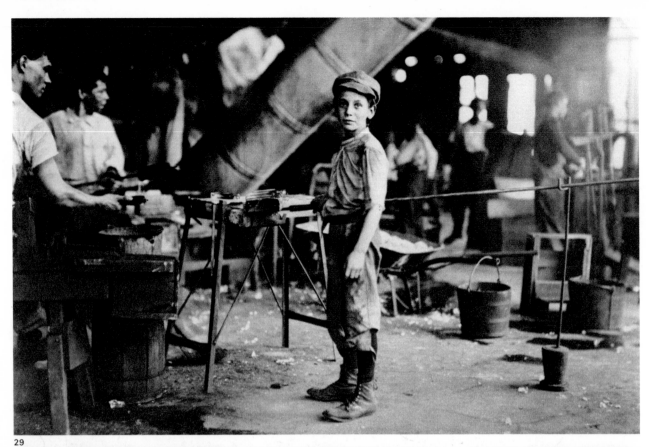

29

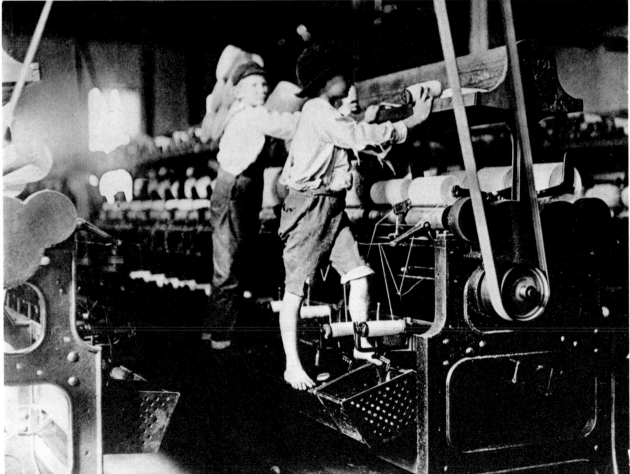

30

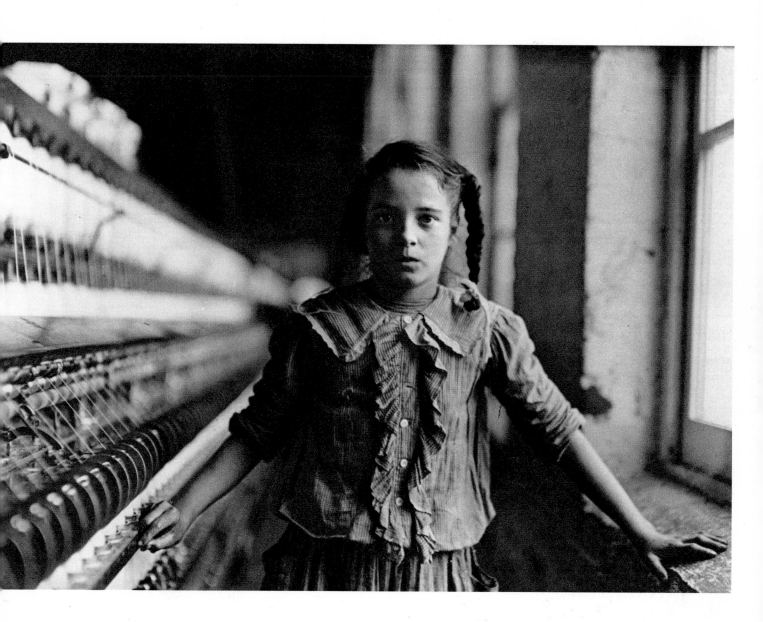

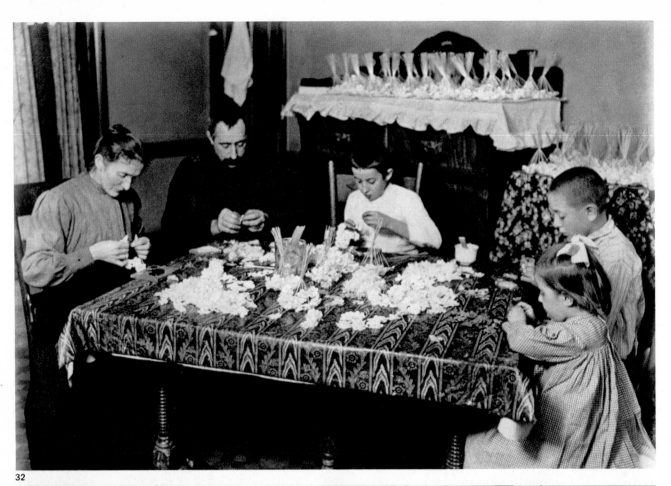

32

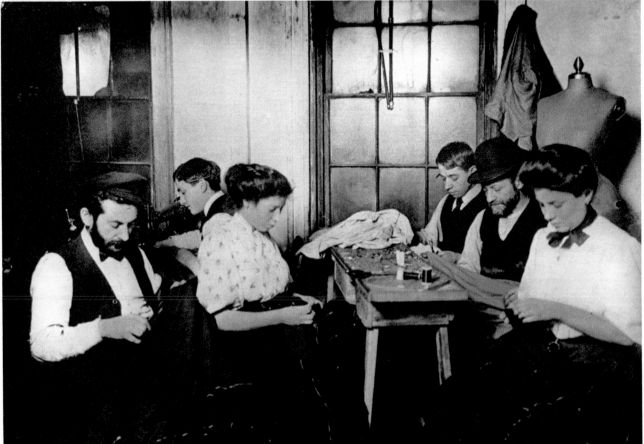

33

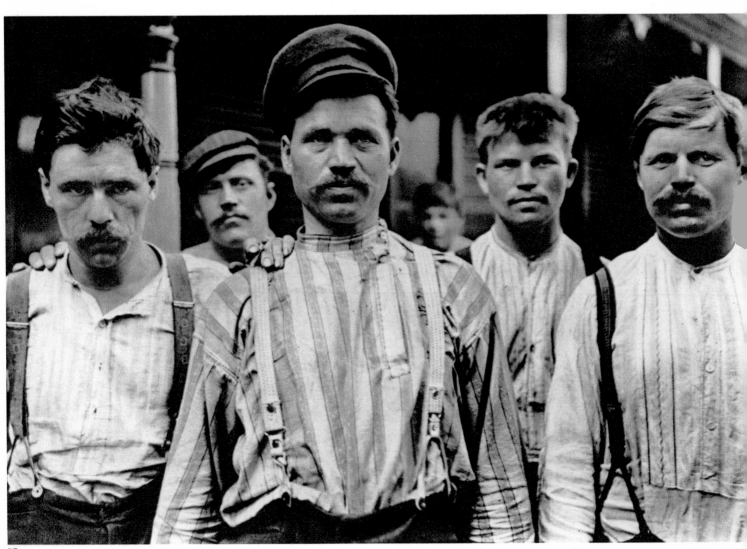
35

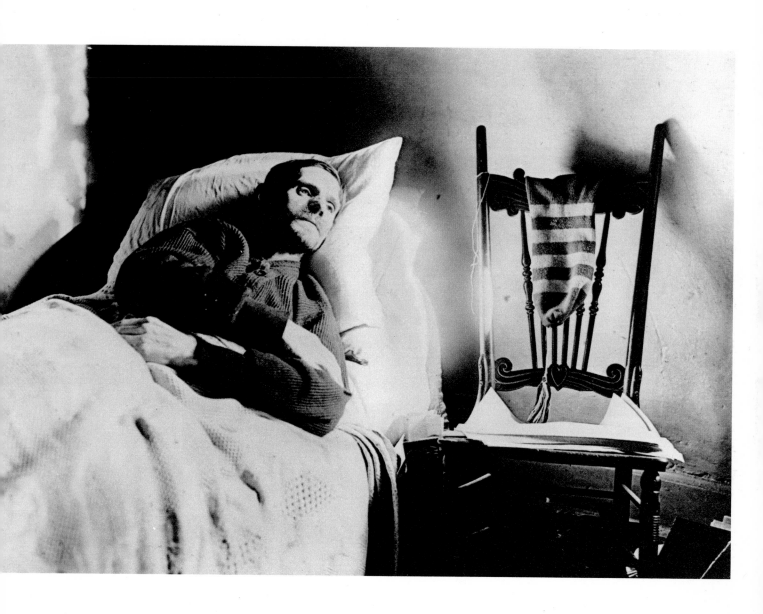

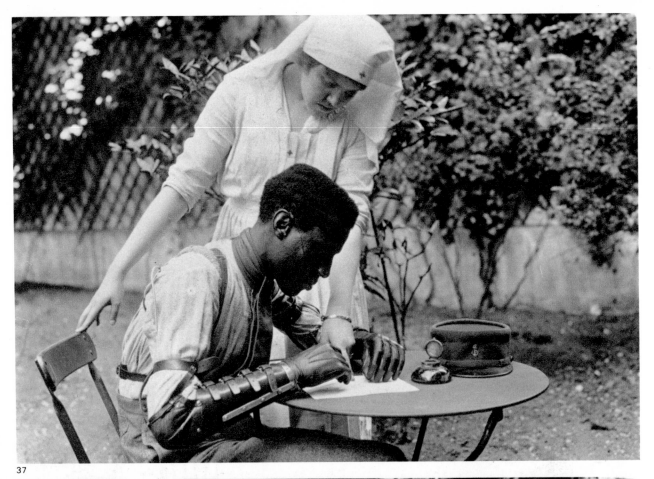

37

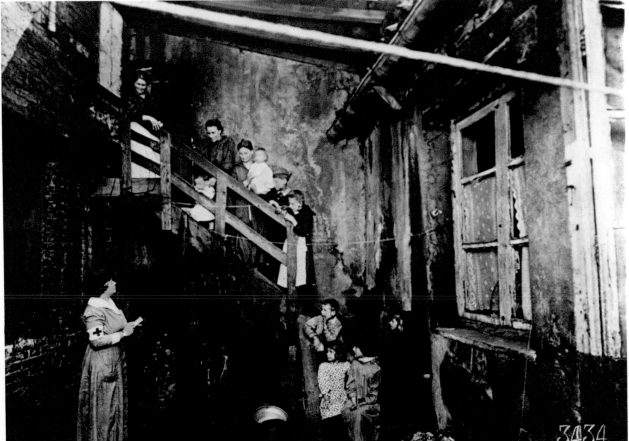

38

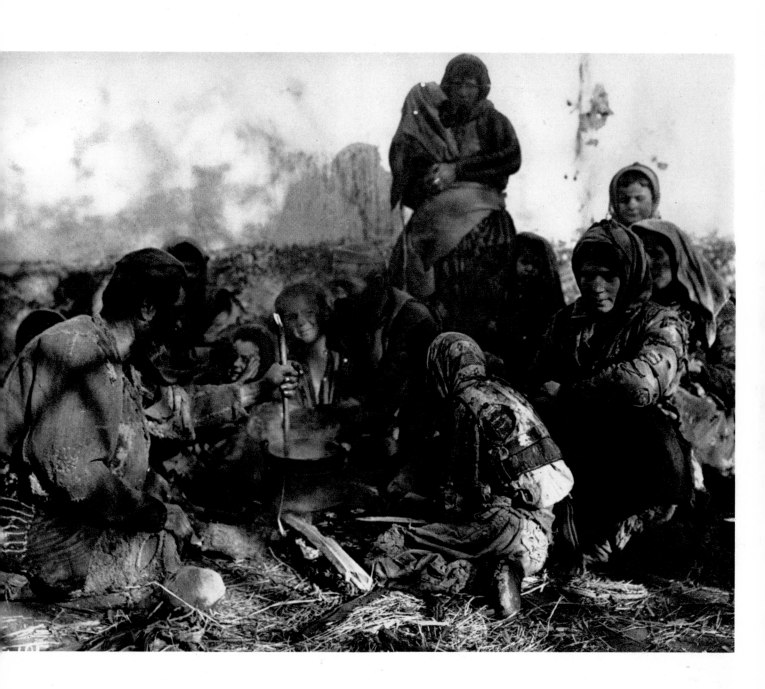

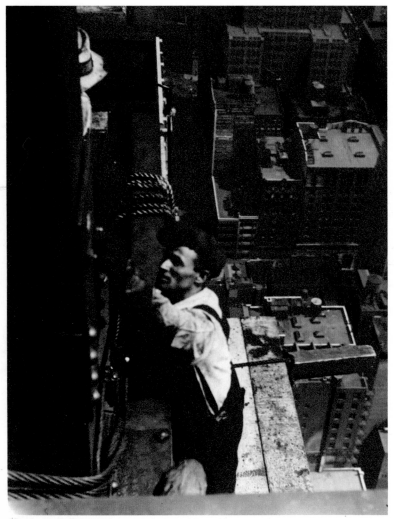

40

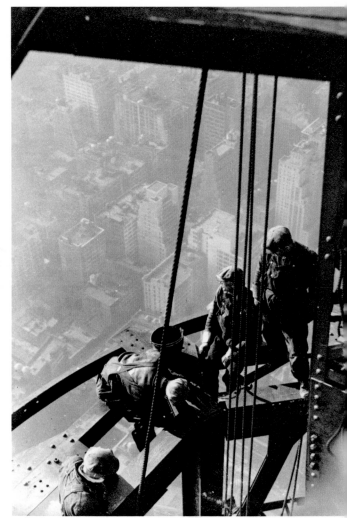

41

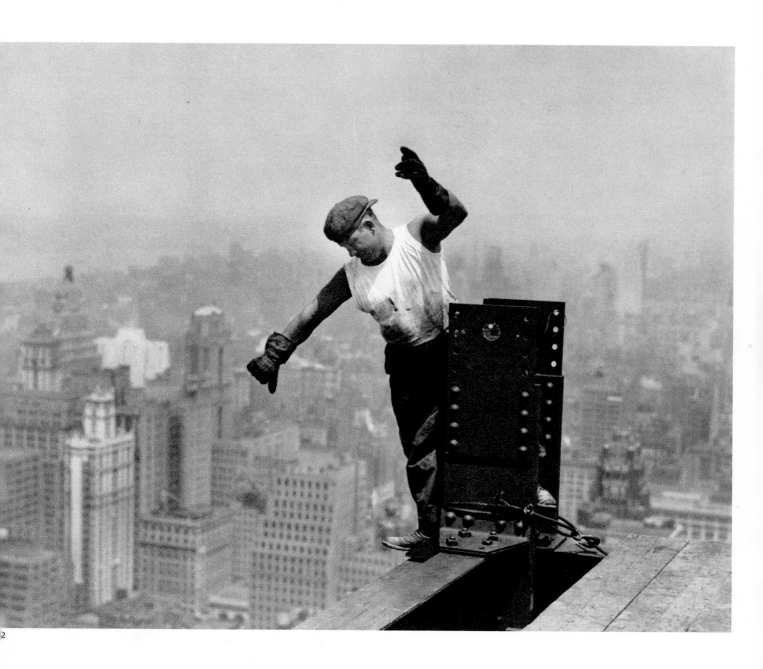

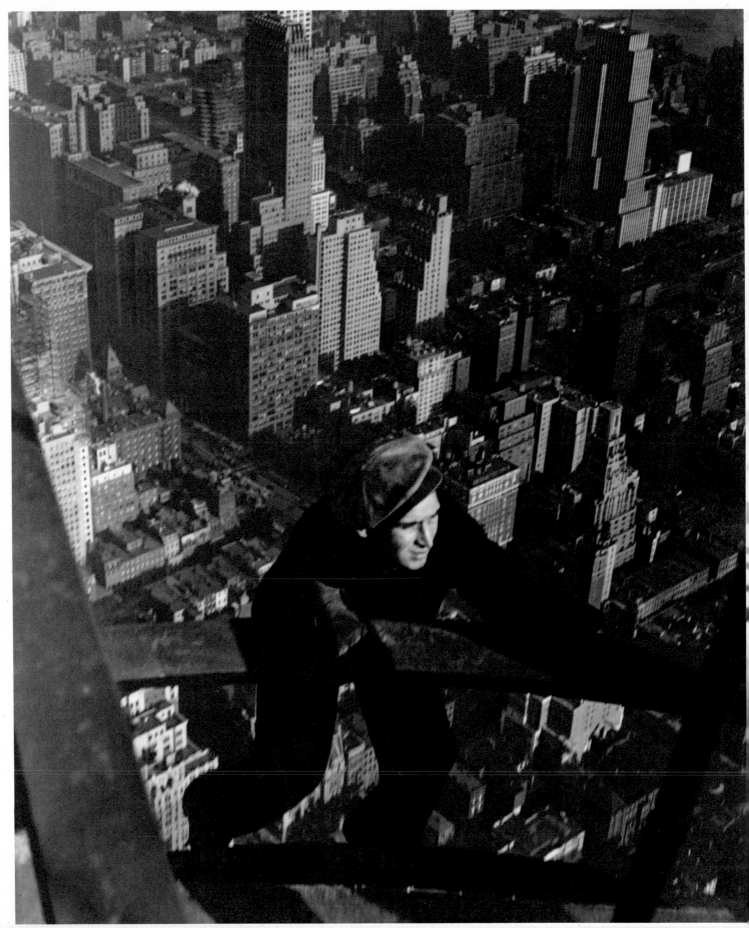

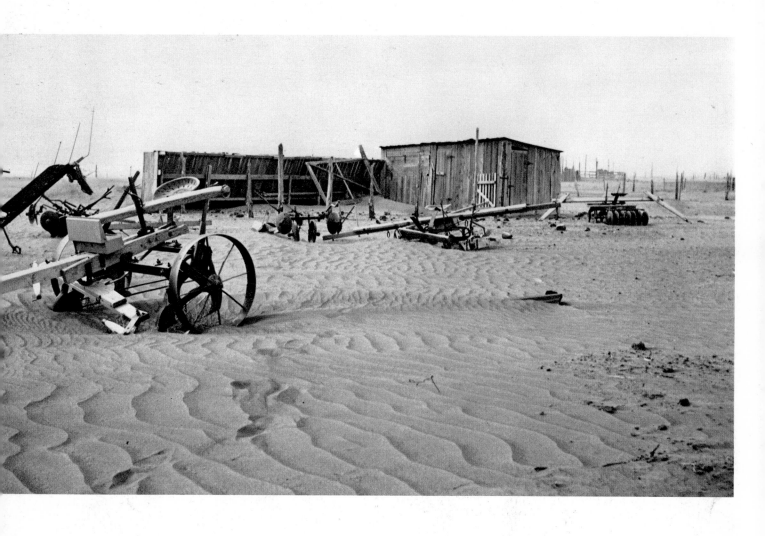

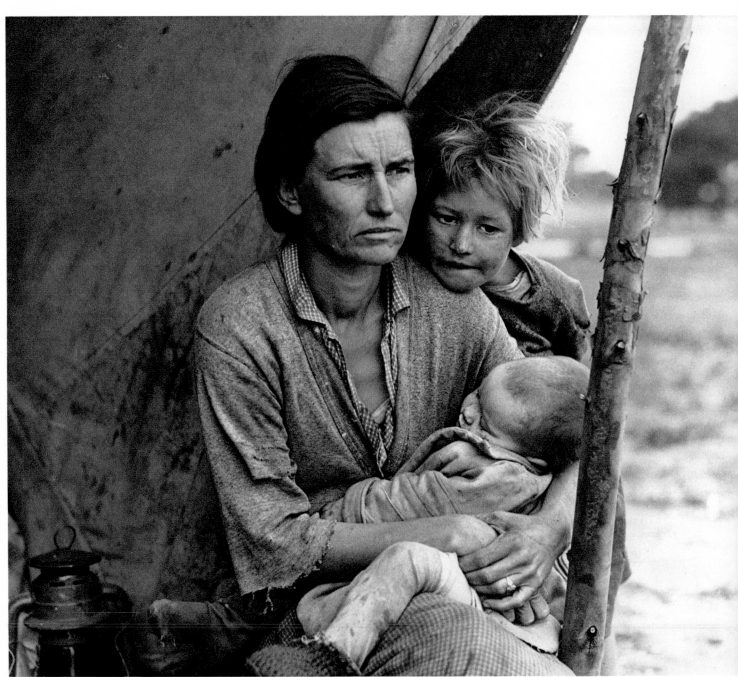

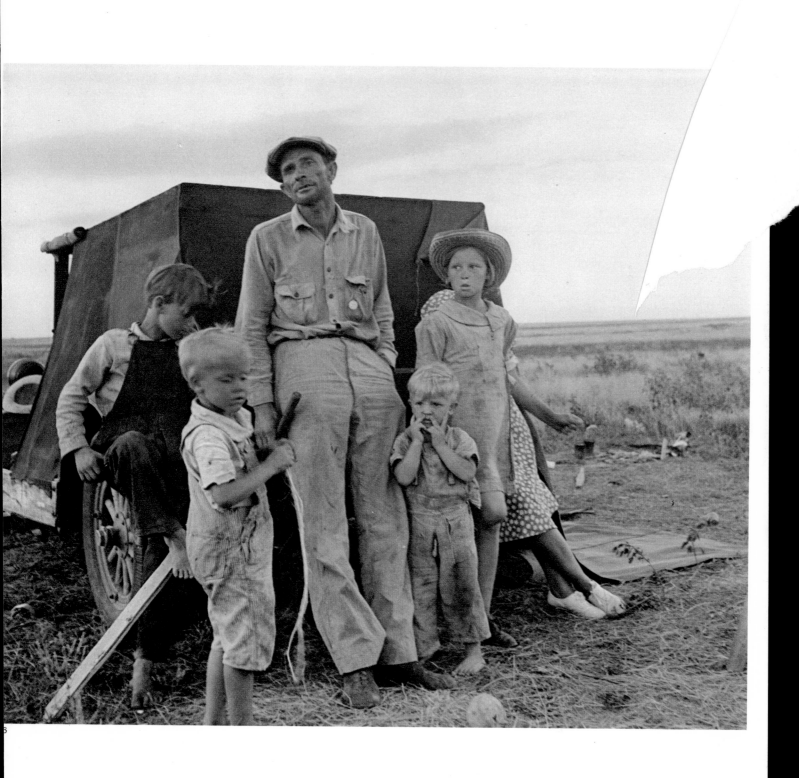

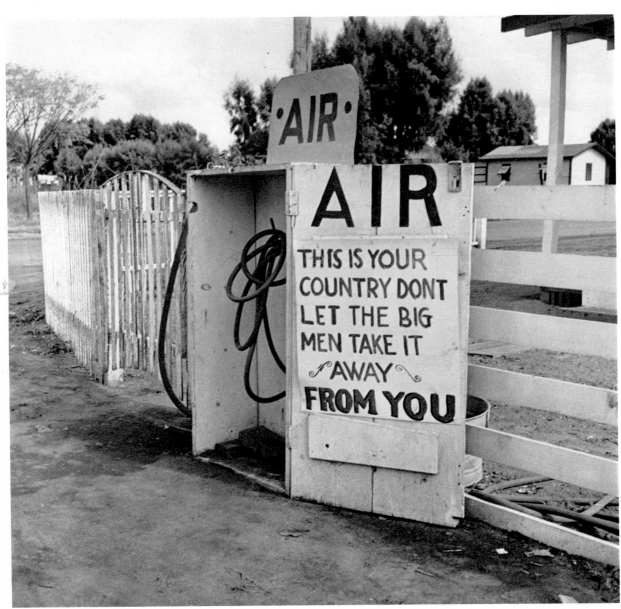

47

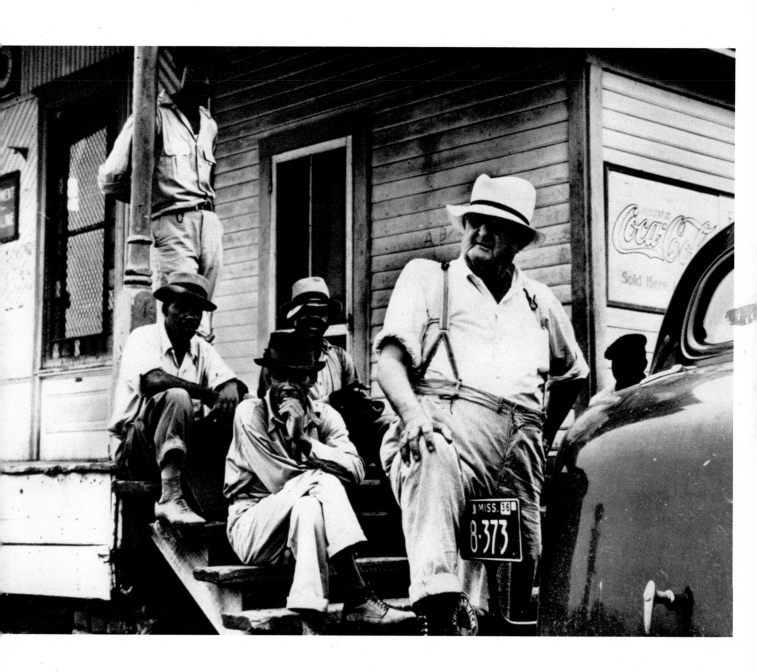

Walker Evans

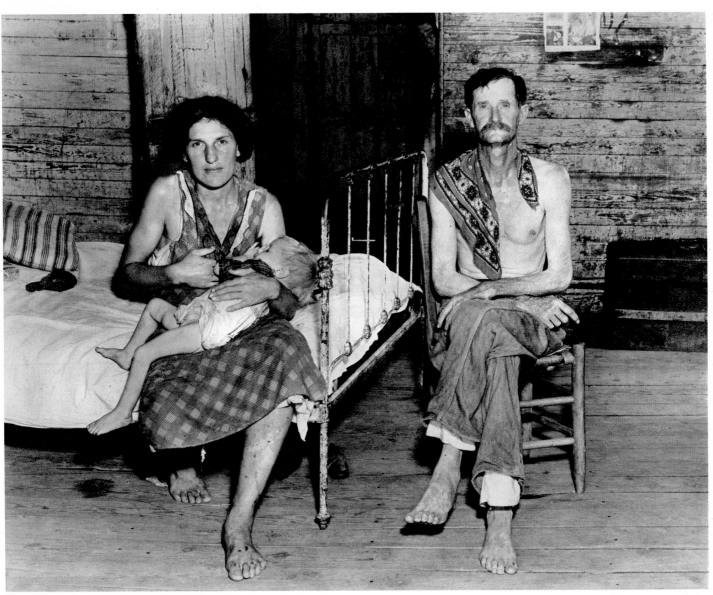

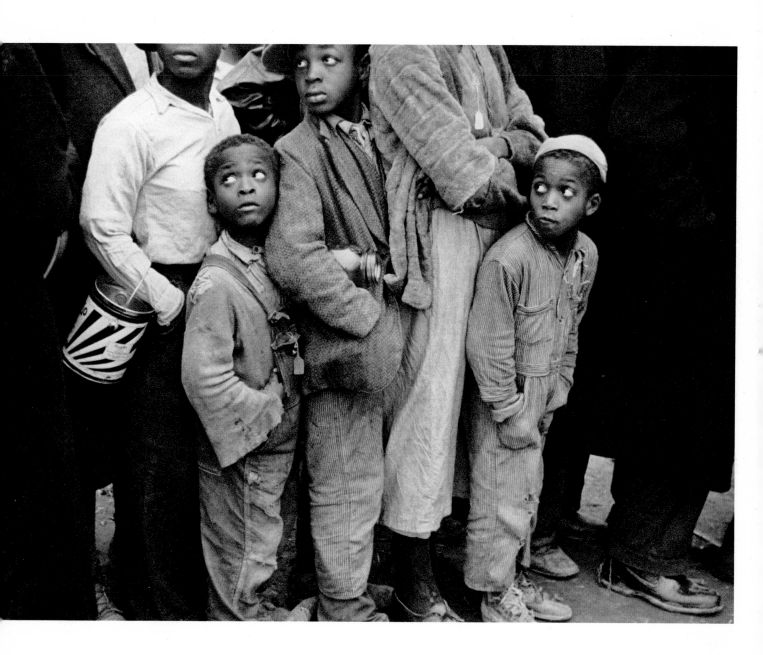

Arthur Rothstein

54

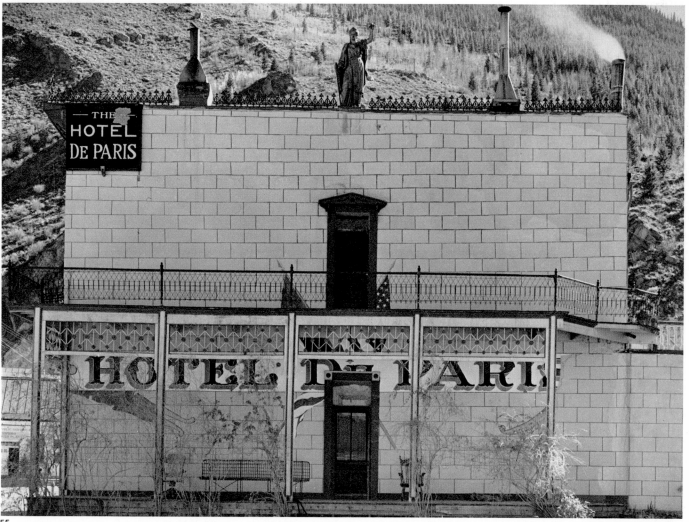

55

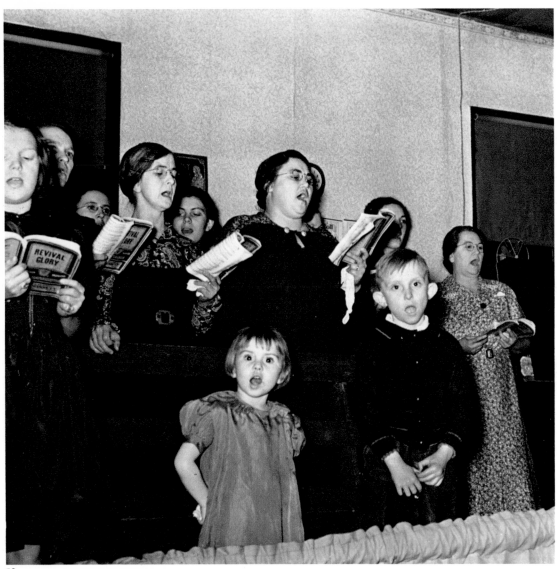

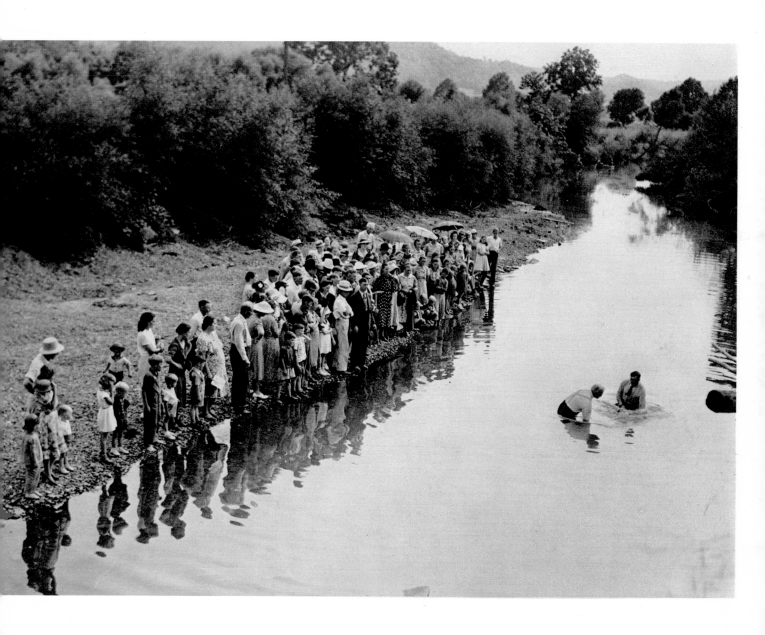

Carl Mydans

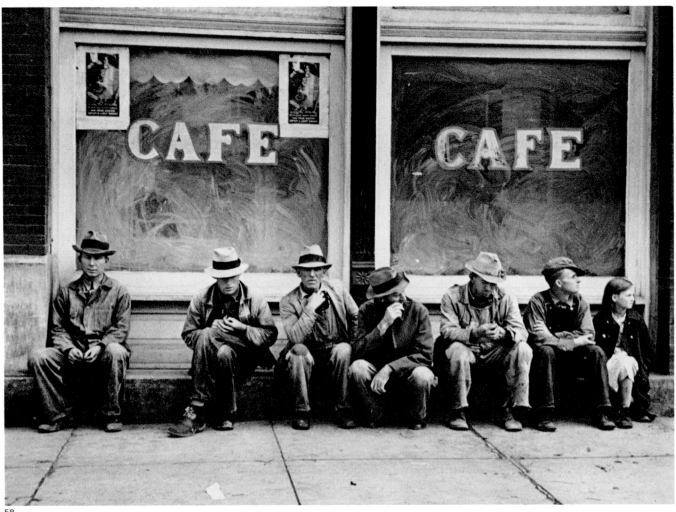

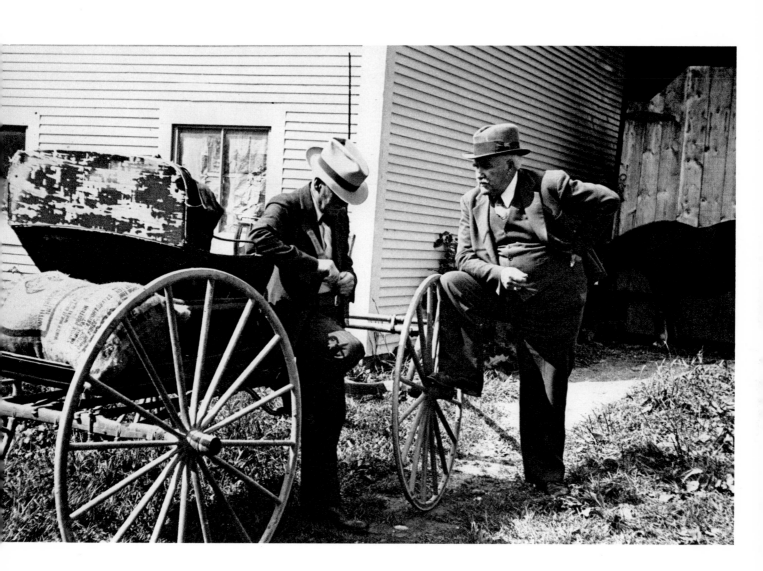

Ben Shahn

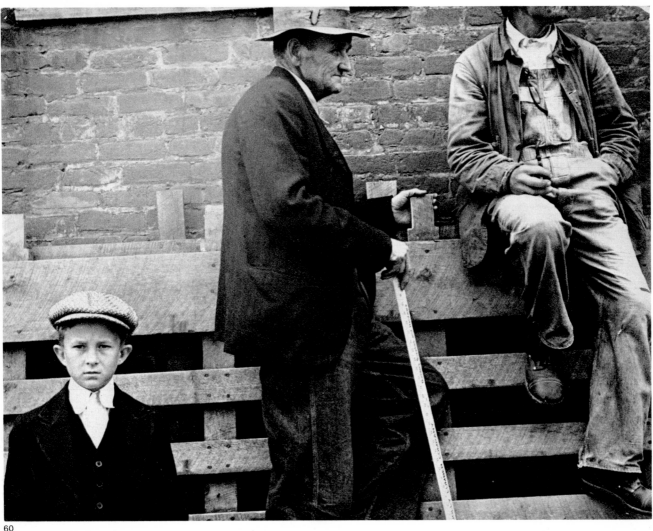

60

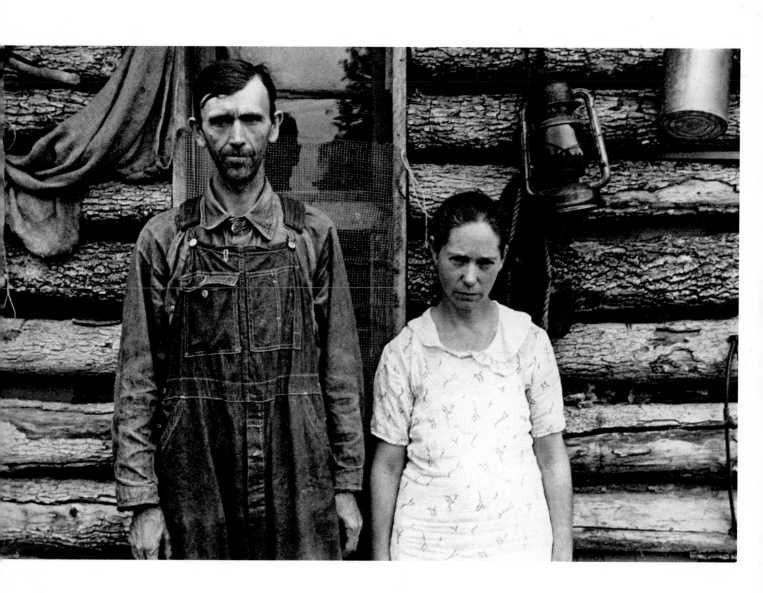

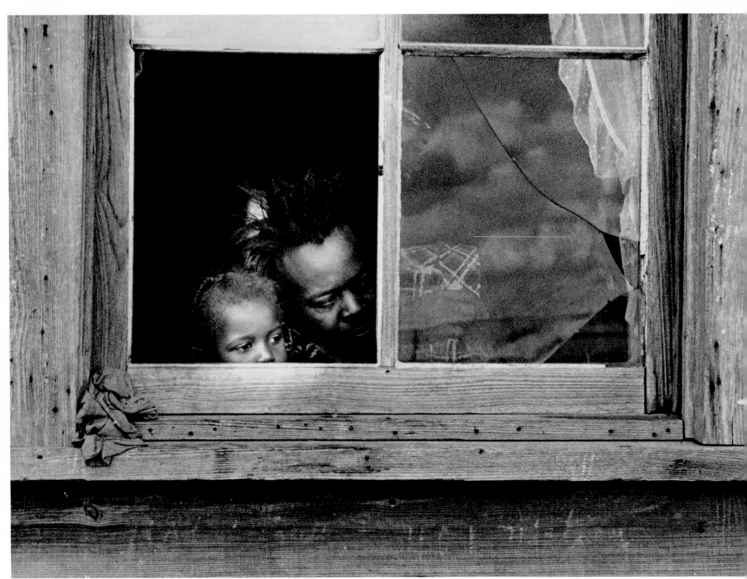

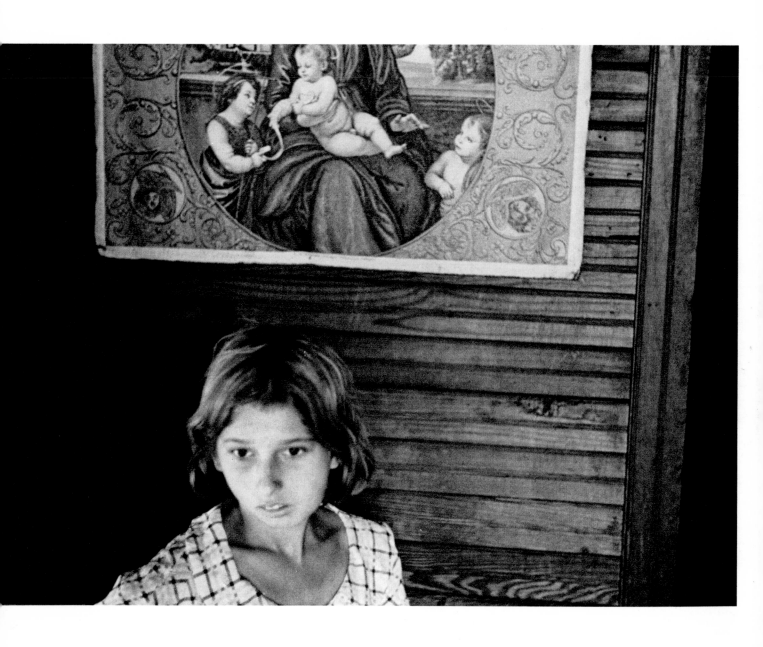

Jack Delano

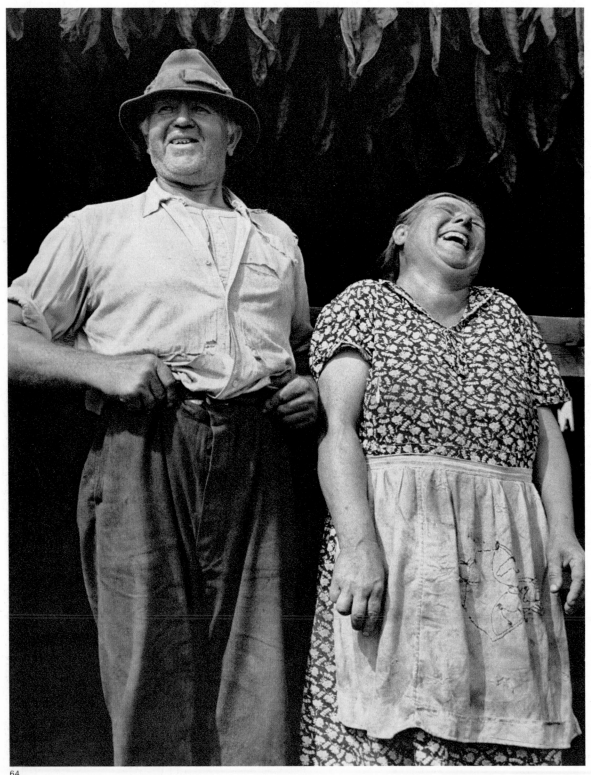

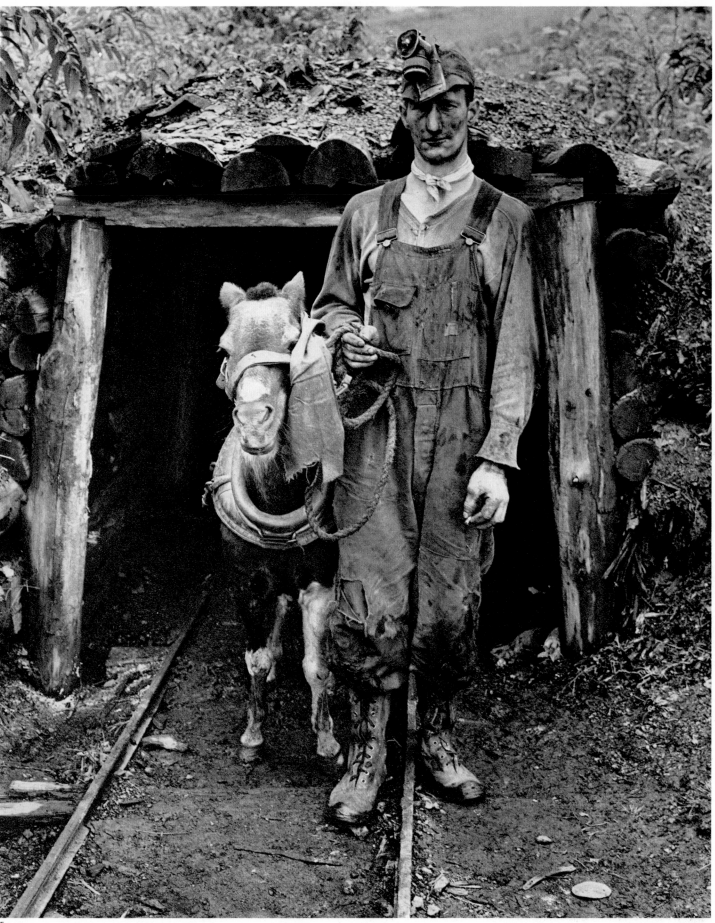

Russell Lee

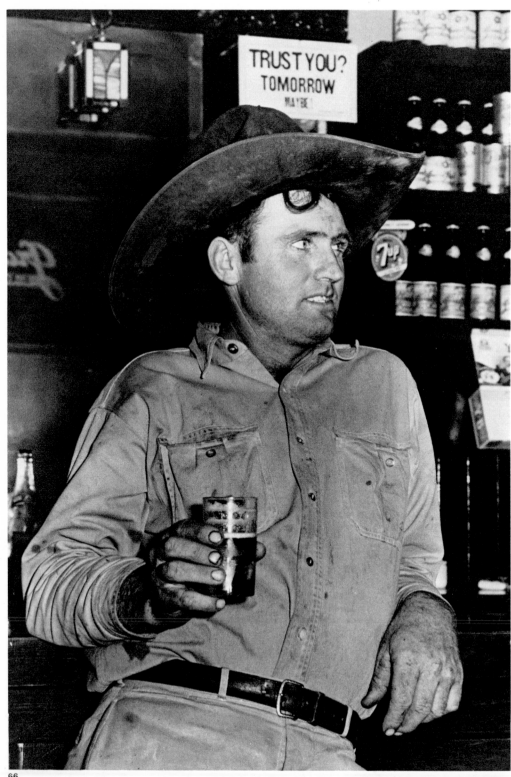

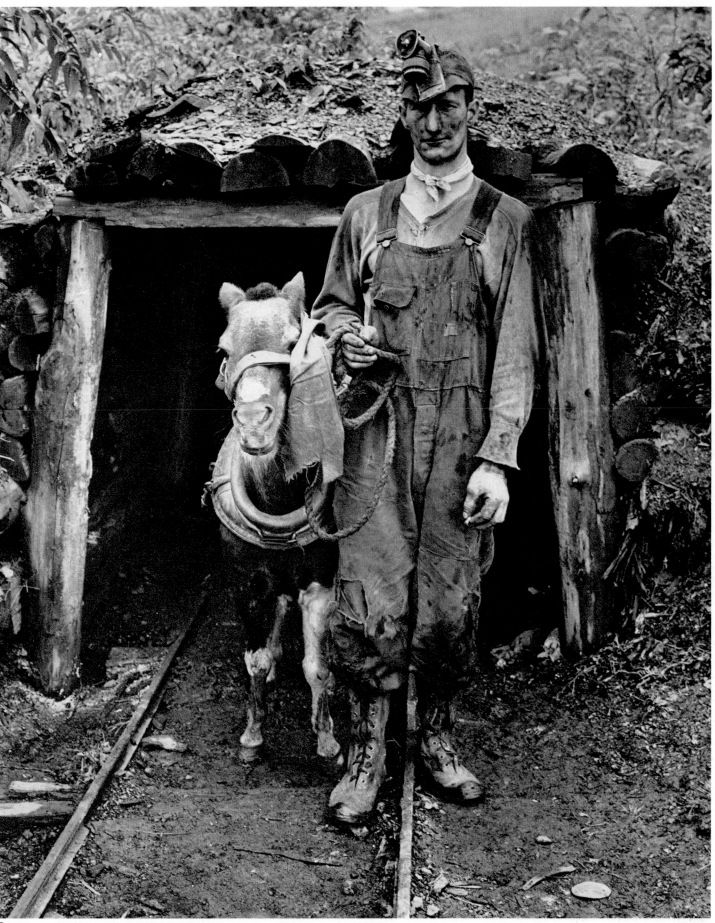

Russell Lee

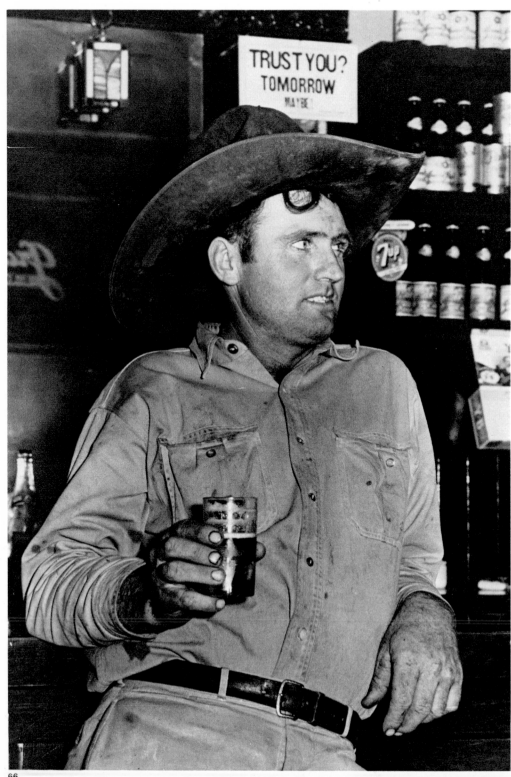

Paul Carter

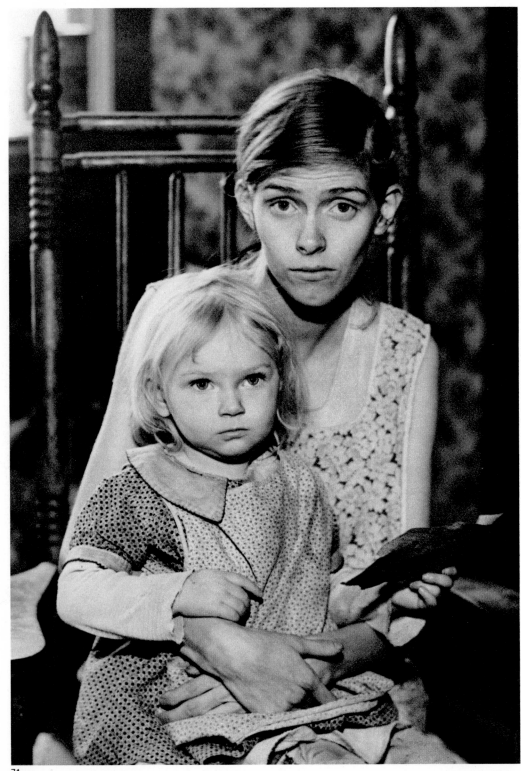

Gordon Parks

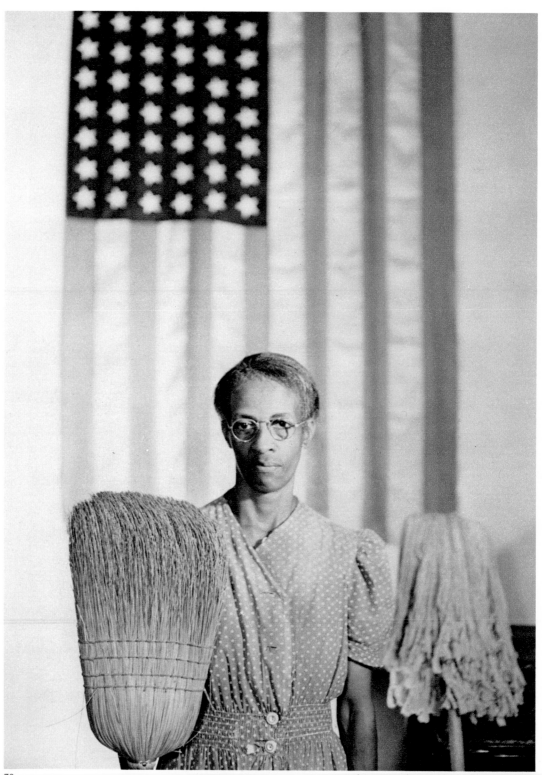

Palmer

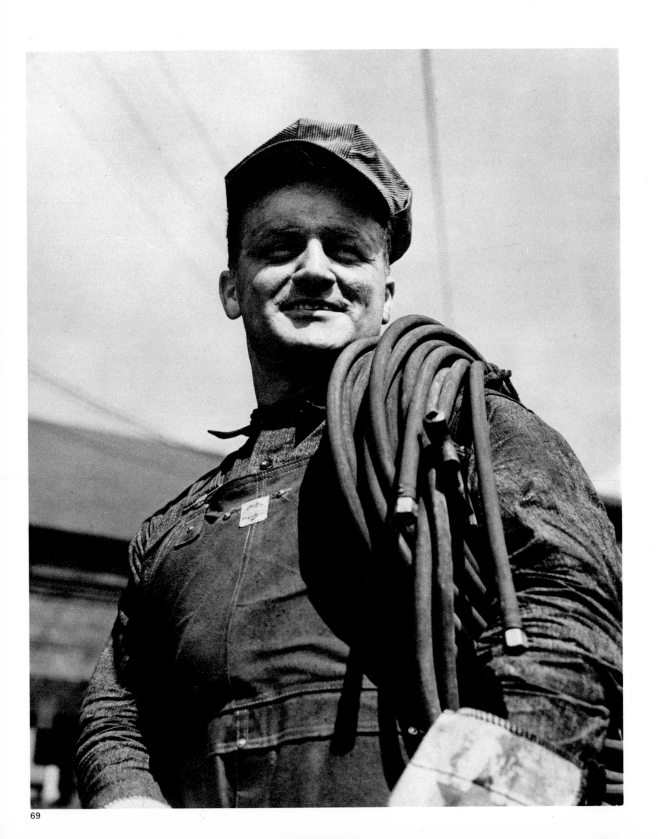

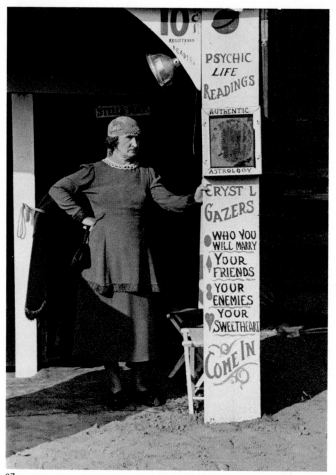

67

68

John Collier

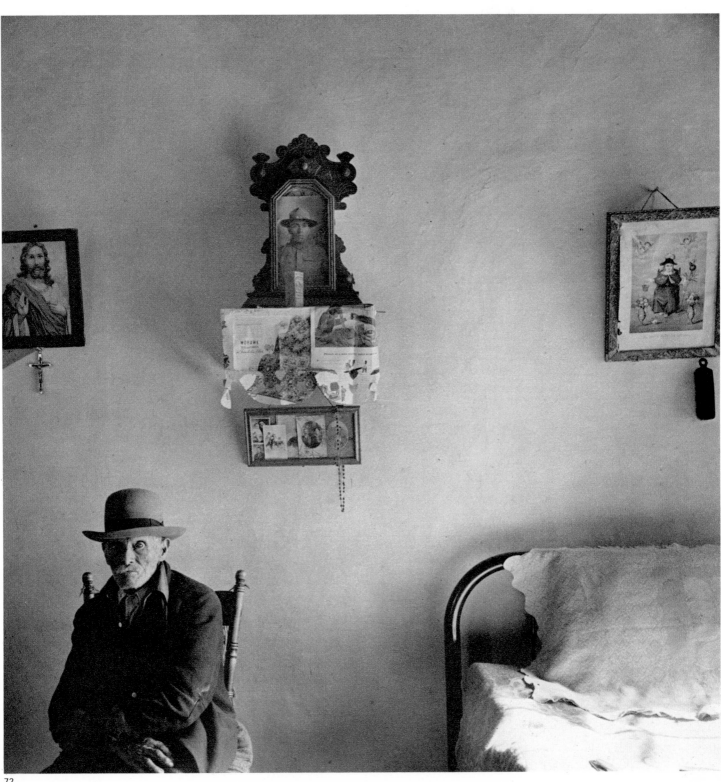

John Vachon

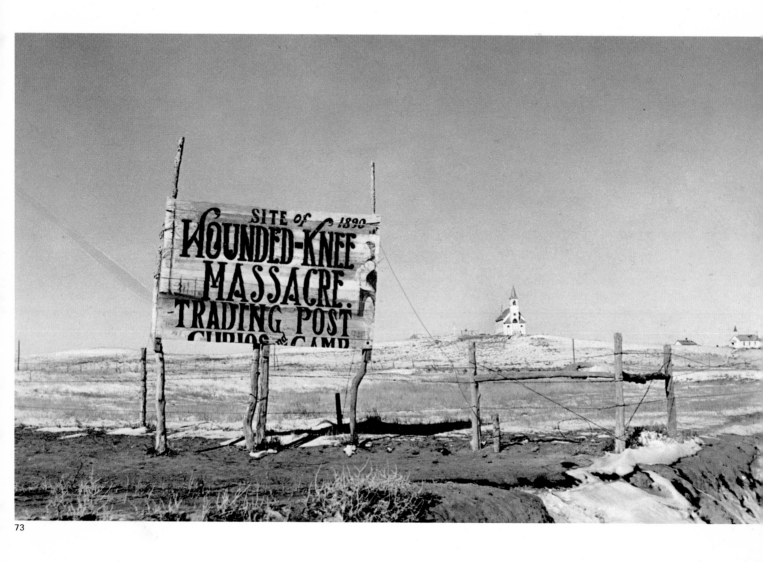

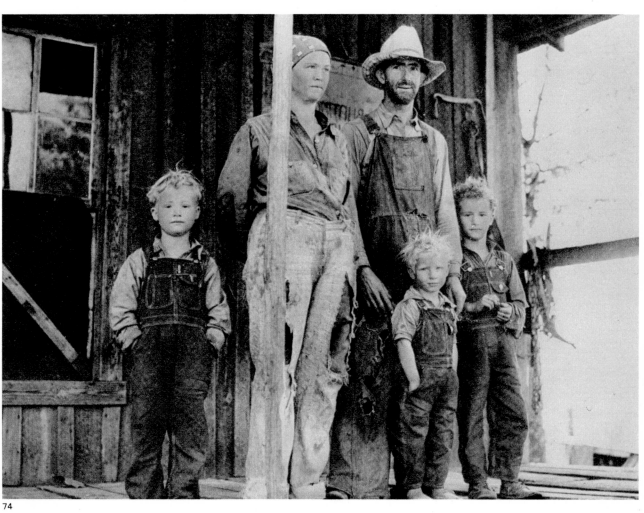

74

tion 49, which contains some of the same subjects as Illustration G. One curious element, which may cause confusion in the FSA files, is the numbering system. These two Evans pictures follow each other in number, being only one digit apart, while the Lange pictures mentioned above are separated by 35 numbers. If one assumes that the FSA file numbers do, in fact, represent the order in which the pictures were taken, it appears logical that one of the Evans should follow the other. This assumption applied to the Lange pictures poses a question of what happened in between the taking of the "Mother" on two different occasions?

The first real recognition of the FSA pictures from the world of serious photography came in 1938 when the photographs were exhibited at the International Photographic Exhibition in New York. Following this exhibition, the photographs were published in the annual *U.S. Camera 1939.* Edward Steichen wrote an introduction to this special section, extolling the FSA pictures with this comment: "If you are the kind of rugged individualist who likes to say, 'Am I my brother's keeper' don't look at these pictures—they may change your mind."

Steichen also commented in his review of the *U.S. Camera 1939:* "They [the FSA photographers] also found time to produce a series of the most remarkable human documents ever rendered in pictures."

One other matter for consideration is Evans's almost exclusive use of the 8" × 10" view camera for all his work. There are some examples where he did use a Leica, though, and he is known to have recommended its use to others. Because of the nature of Evans and his method of working, he produced very few but very excellent pictures. The slowness of Evans, due to his attention to the artistry, caused considerable frustration for Stryker who in desperation once pleaded with Evans to abandon his 8" × 10" and use the Leica. Apparently Evans yielded to this request, because there are some examples, such as Illustration 50, which is a 35mm picture that dates about the time of Stryker's exhortations.

Stylistic characteristics are another element worthy of note, which can be seen by comparing Illustration 50 with Illustration 60, which is the work of Shahn. Shahn and Evans shared a studio in New York for several years, and it is known that Evans introduced Shahn to the Leica. Shahn used the

Leica extensively for gathering notes for his mural work in the early thirties. It is not at all certain who influenced whom in this comparison, but there is obviously a cross fertilization that seems to be more than just the effect of a particular tool. Evans's work with the 8″ × 10″ camera is certainly quite unlike that of Illustration 50.

Evans had a profound effect upon the entire FSA project and thus, in turn, upon the whole field of photojournalism for nearly three decades to follow. Cliff Edom of the University of Missouri School of Journalism said, ". . . soon Stryker's photographers had developed a brand of photography peculiarly their own. Their pictures, it seemed, embodied the painstaking technique of the photo purist . . . somber, austere, shorn of any ornamentation or embellishment, FSA pictures, through accent, contrast, rhythm, composition, fairly shouted their story. . ."

While Edom did not identify Evans as the source of this influence, it is clear from studying Evans's early work for the FSA and seeing the obvious influences that Evans was the source. Examples for comparison are Illustration 57 by Evans and Illustration 58 by Carl Mydans, taken at the same time the two worked together for the FSA.

"The Bitter Years" was the title of an exhibition on the FSA, which was assembled by the late Edward Steichen, the patriarch of modern photography. This exhibition was Steichen's "swan song," in that it was the last exhibition he organized before leaving the Museum of Modern Art where he had been Director of Photography since 1947. It is unfortunate that this title was chosen for an exhibition, although understandable. Many of the photographs from the FSA project showed hunger, want, deprivation, and the result of many years of the misuse of the land by the people. The FSA documentary project also showed, in almost equal proportions, the beauty of the land and the people, and joyfulness and the pride of the people in themselves, their homes, their work, and their land. One long overlooked aspect of this collection is the total breadth and scope of it in representing *every* aspect of rural America. Theodore M. Brown in his book on Margaret Bourke-White states that "The scope of the FSA material was so broad and varied that it could be used to paint many different Americas." It is almost as though Stryker too carried out the objectives of Lewis Hine

in showing all sides of life rather than just the seamy and unsavory. Stryker wanted to show all that made America "tick."

It is possible to put together an overwhelming statement reflecting the poverty of the period, but it is also possible to illustrate the resilience of the people of rural America by showing their joy and pleasure. There are pictures of the fun and games of these people. One of the incredible things about pictures about poverty is their magnetic ability to evoke emotional response. Harry DeWald, a notable industrial photographer who taught for many years at the University of Louisville, always challenged his students to produce emotionally charged photographs of the same little girl in white gloves and fancy dress as they did of the little grubby girl in the slum setting.

If any single message comes from this presentation of the FSA, it is that the FSA was, in fact, a broad view of America, not just a view of a depression and the misery it produced.

One finds substantial indications of the foundations of "Pop Art" in the works of Walker Evans, John Vachon, Russell Lee, and others, Illustrations 52, 73, 54, 68, and of the new realism in Illustration 55. Some of the experience of the thirties was bitter, but this is true of any era. The thirties had its share of joy too, Illustration 64. The fat farmers and the poor farmers are represented. The small business and the large, hand labor and machine, patriotism, Illustration 70, and those critical of the government, Illustration 47, can be found.

Many people, particularly in America, labor under the delusion that the purpose of the FSA documentary project was akin to that of the WPA (Works Progress Administration) or the subdivisions of the WPA, such as the Federal Art Projects and the music projects, which were aimed at providing work for artists and musicians who were unemployed during the depression. John Szarkowski of New York's Museum of Modern Art says in his introduction to *Walker Evans*, that the FSA was a "make-work project of the depression period." It is easy to understand the inclination to identify the FSA as this kind of thing in a government that was so involved in alphabetically named make-work projects. But it is also clear that a project which had no more than six photographers on the payroll at any one time would do little to care for the starving photographers of the depression.

It is also time to explode the myth about the sanctity of the image and its relationship to the artist-photographer. The FSA project started as a "Picture Book of American Economics" as stated in the *Washington Daily News*, December 18, 1935. Stryker's photographers started working, and the purposes began to evolve out of what appeared in pictorial form. Obviously, from the early uses of the FSA material, the propagandistic value of the work was recognized, and soon after Walker Evans began working for Stryker, there exist letters from Stryker, imploring Evans to produce more pictures because the bureaucratic demands were running high. In the history of the project, Evans and Lange were the only significant people, of the total of more than 20 involved, who held out for the purity of the "art" of their photographs. They are also the only two who can be relied upon to have had a hand in determining the actual print quality and the cropping of the photographs. While not a foolproof assumption, many of the early prints of the Lange and Evans photographs were probably made by the photographers themselves. This happened with a few of the other photographers, but rarely. More often, weeks or months elapsed between the taking of the pictures and the photographers first seeing the proofs. The films were mailed to the laboratory in Washington, and when the photographers came back to Washington after many weeks or months in the field, they were subjected to an intensive review of their work by Stryker. The information relative to each photograph is extensive, and the use it was put to was very broad. The format of the pictures varied, depending upon the use. A good example of this is Illustration J compared with an alternate cropping as seen in Illustration 71. Another interesting application of an FSA photograph is seen in the work of Ben Shahn. Shahn, who later became famous as a painter, used the camera extensively as a sketchbook for gathering material for his murals and paintings. One such application is Illustration H compared with the original FSA photograph, Illustration 61.

There was bitter resentment of the parent FSA efforts. The resentment was often accompanied by violence that was never recorded by the photographers. The resentment centered about the fact that the government's aid to the small farmer and the sharecropper would provide them with an

independence that would foil further exploitation by the privileged landholders. To some extent, the resentment colored the direction of the FSA where "the small family-sized subsistence farm became the ideal unit. It was nourished by a social work approach rather than an economic one because it would avoid additions to the large commercial crops," said Mitchell in *Depression Decade*. Large landowners, who exploited sharecroppers for their labor, were not about to lend enthusiasm to any program that placed these sharecroppers on an independent level beyond the reach of exploitation. The assistance programs then functioning were not related to the broader concept of whether the small farm had a place in the economy, but simply assumed that the small farm was a viable entity.

In 1939, Rothstein unearthed a very unsavory situation between planters and sharecroppers, in which the planters were using their economic "muscle" to thwart the freedom of the sharecroppers. On some occasions, like Rothstein's trip to the mining area of Alabama, the photographers were subject to abuse by those resenting the FSA's attempt to state the truth about the plight of the less fortunate.

As World War II approached and became a reality, the FSA project changed direction in a way that alienated the sensitivity of Stryker. During the flowering of the FSA project, Stryker was able to maintain and defend the integrity of the entire project because of his determination to show honestly and eloquently the reality of America. Even today, the surviving FSA photographers are a little starry-eyed about the nobility of the project. The fact that the FSA efforts were used for propagandistic purposes was not offensive, because this was dissemination of the "truth." By March of 1942, the change from the objectives of the FSA to those of the Office of War Information became a reality. By September of that same year, the FSA was dead and the OWI took over the use of the FSA files. The pictures continued to be used for propaganda purposes, but the objective was to convince the rest of the world that we were big, real, committed to the good life, and that we would help our allies because we were so "good." Oddly enough, the propaganda that the FSA provided, without restriction, was picked up in Washington and used by the communists to show how capitalism had failed. Several of the pic-

tures were used in German SS training periodicals to show "The Land Without a Heart." When the object of the pictures changed from essentially "truth" in the old FSA sense to the outright manufacture of propaganda for the OWI, it became offensive to Stryker. Perhaps the best way to explain this conflict is to compare the difference between saying that the charge to the FSA photographer was to "find truth" while that of the OWI photographer was to "show truth." It may be an unfair comparison, because interpretation can sometimes be mistaken, but Illustration 64 has a strong element of pride, dignity, and humility. Illustration 69, taken to symbolize a nation at war, has an element of arrogance that doesn't ring clear. Gordon Parks's "Capitol Scrub Woman," Illustration 70, seems to fill the gap between the previous two in that it uses otherwise trite symbols for a serious statement.

The efforts of Stryker, presented here, occupy only a few years of his life's work; therefore, it seems reasonable to indicate Stryker's total efforts. Although the FSA died with the advent of World War II, this did not end Stryker's career of directing photographic projects. Stryker moved to New York in 1943 and spent most of the next decade documenting the effects of oil in the life of man on a worldwide scale. A single illustration, 75, taken in 1948, is included in this book to show the continuity of thought in Stryker's efforts. Paul Vanderbilt, who worked briefly with the FSA Collection under Stryker, stated in 1972 that he believed that the Standard Oil of New Jersey project was Stryker's greatest effort in that it had "more bite" than the FSA. Vanderbilt rose to fame in his own right in organizing the picture collection of the State Historical Society of Wisconsin, one of the model efforts in this country. Stryker did not even stop with the Standard Oil, but continued for yet another milestone in documenting the Steel Industry for Jones and Laughlin Steel Company. The J&L project carried Stryker's ideals to an even higher level of professional competency. Perhaps the stigma attached to these two company-oriented industrial projects will eventually wane, and their full impact will be realized.

Riis, Hine, and Stryker not only altered the social conditions of their respective eras, but they established a position for photography as a tool of communication. Although printing had existed for nearly 500

International Museum of Photography at the George Eastman House.

During the productive years of Hine he had a wide variety of causes: child labor, coal mines, sweatshops, the immigrant poor, and the suffering imposed upon Europe by World War I. During Hine's travels in Eastern Europe for the Red Cross after the war, he decided that he had more to contribute than simply exposing the unsavory side of life, and it was at this time that the idea for the documenting of *Men at Work* formed in his mind. It is curious that while Hine is more well known for his seamy-side-of-life pictures, the first significant book of his work is, in fact, *Men at Work*. He devoted the greater part of his life to photographing the magnificent accomplishments of man.

When Roy Stryker began his work in 1935 as Chief of the Historical Section of the Farm Security Administration (first known as the Resettlement Administration), he had no plan other than that of recording in an historical sense the efforts and programs of the FSA. The FSA had clients who were essentially farmers unable to make an adequate living off the land. The FSA, through loans and basic educational programs, aided these people in becoming self-sufficient. The program worked, and there is indication that had World War II not happened when it did, the plight of the farm people of the United States might have been resolved, at least for a time. The farmer's plight in 1935 is assumed to have been a result of the Great Depression of the thirties; however, the farmers were in a sorrowful state long before the stock market crash of 1929. The real beginning of the farmer's depression was in 1922 when the federal government discontinued the "give away" to European countries whose agrarian programs were devastated during World War I. When this stopped, the bottom fell out of the farm prices, and the struggle for survival of the small farmer began. After more than ten years of misery, aid in the form of the Farm Security Administration began to arrive. The ills of the rural world were far removed from the urban centers, and the farmer's problems were little known by the majority of the population.

It is interesting to note that an appraisal of the parent FSA program (of which Stryker's efforts were a small part), made in 1940, indicated that the standard rehabilita-

tion borrowers increased their net income by 35 per cent over the previous year before coming on the FSA program, and the value of all their belongings, minus all their debts, by 20 per cent. At that time, the FSA estimated that 80 per cent of all loans would be repaid. Up until 1941, the FSA loaned a total of $574 million to 900,000 families. Including probable losses, the cost was about $75 per family, contrasted with more than $350 in direct relief, which did nothing to improve the permanent status of the family.

Whether the "New Deal" of Roosevelt would have worked or not is still the subject of debate. The answer never came, because World War II and its subsequent effect on the American economy made the "New Deal" a moot point. Economists and politicians were concerned about the economy, and the "New Deal" was a proposed method of restoring a depressed economy to a healthier position. The man on the street knew little and understood less about the sophisticated reasoning of the "New Deal." He did understand the eloquence of President Roosevelt and the appeals to the masses of this country when he asked for their support for his programs. When he asked in 1937 for support because "one

third of the nation is ill-housed, ill-fed and ill-clothed," the documentation of these facts had already been established by the Historical Section of the FSA, and the images of these facts had already become symbols that are still deeply etched in the minds of those people who were victims of the Great Depression.

Stryker, to this day, maintains there was no "grand plan" for his project. He says that the project just grew as the dictates of the pictures taken were revealed. In a sense, he is saying that when the message of a picture was realized, the use of that picture could be determined. It may be true that there was no grand plan in the beginning, but the evidence of the operation of the Historical Section of the FSA indicates that a grand plan was functioning, if not clearly defined, within a very few months of the establishment of the FSA Historical Section. Shooting scripts and directive letters to photographers in the field clearly indicate that there was a "clientele" that had to be satisfied in the early days of the FSA.

In 1938, when Stryker was interviewed by the *Washington Post*, he displayed his awareness of the importance of the FSA Collection. He commented that "These rec-

ords are extremely valuable to the students of American social history."

In 1938, Archibald MacLeish wrote a book entitled *Land of the Free*. MacLeish maintains that his book is a book of photographs, which has been illustrated by a poem. *Time* reviewed this book, from which comes the following comment: ". . . most people, however, will agree that these superbly taken, brilliantly presented photographs are the most excoriating testimonial yet published to the gutting that U.S. citizens have given the American continent, and that the continent is giving back to the U.S. citizens." Robert Given, Chief of *Life* New York News Bureau said, ". . . never before or since has photography made so many people conscious of a social problem. . ."

Dorothea Lange's "Migrant Mother," Illustration E, is probably the most famous of the photographic icons from this or any other period. This particular photograph has been used in almost every civilized country in the world for a host of purposes. In 1969, it was estimated that this one photograph had been used in more than 10,000 separate editions, being reproduced many hundreds of thousands of times.

In addition to Lange's "Migrant Mother," Rothstein's "Dust Bowl," a picture of the family struggling against the wind, is the second most known symbol of this period. This picture, together with Lange's and the film based on Steinbeck's *The Grapes of Wrath* are the collective symbols of the period. The "Dust Bowl" is the most symbolic phenomenon of the whole depression period. While the dust bowl flowered in the thirties, its origins go back to the period of World War I when the farm areas of the Plains States were so productive. The dust bowl came about through improper farming techniques and through exhausting the potential of the land by the high productivity of the war economy. When the land rebelled from misuse coupled with a period of extensive drought, dust storms inundated the land and practically every living thing became a victim of the dust. Pare Lorentz, the great documentary film maker, was employed by the Farm Security Administration at this time, and during his tenure with the FSA, he made one of the fine documentaries of the thirties called *The Plow That Broke the Plain*. This film was based on the dust bowl and the attempts, which were to prove successful, to stem the tide of

dust. Lorentz's role in the FSA is often confusing with relation to the Stryker-directed project. Lorentz was not part of the Stryker-directed Historical Section but rather a part of a separate film section.

Some interesting, though little known things surround these symbols of the thirties. The "Migrant Mother," Illustration E, was a subject of some controversy within the FSA. Stryker was concerned with the unadorned truth and Lange was concerned with a deep sense of aesthetics, which led her to retouch a thumb from the lower right corner of the "mother" picture. In some early publications, the thumb appears, but in later ones, it is gone. Stryker was disturbed by this "serious lack of taste," and it served to widen a long-standing feud between the two. Stryker was "gun shy" about any possibility of being accused of manipulating his photographs, because Rothstein was once accused of using the skull of a dead steer for a prop to make an area of the Dakotas appear worse than it was. With this unhappy experience, Stryker carefully guarded against any chance of criticism. In recent years, Stryker has stated many times that the "Migrant Mother" is the greatest of the pictures from this project, and time has mellowed his feeling about the thumb. Today, when asked about it, he is more likely to say, "What thumb?" Since the "Mother" is such a well-known symbol of this project, it would be of interest to contemporary photographers to know that the "Mother" is one of several pictures taken of the same subject, and the one reproduced in this work is almost unknown, Illustration 45.

A Steinbeck literary scholar has recently discovered specific verbal descriptions of Lange's photographs in *The Grapes of Wrath*, and there is evidence of Steinbeck's having visited the FSA files prior to writing *The Grapes of Wrath*. The truth of these assumptions may soon be revealed, but it is certain that the FSA photographs were used for staging and costuming the great film of *The Grapes of Wrath* (see Illustrations 44 and 46).

Rothstein's "Dust Bowl," reproduced here, is from the original negative, which no longer exists. Many of the FSA negatives have been lost or worn out, and in the case of Lange, many of them were taken from the central file when she left the FSA.

Another relatively unknown work similar to the Lange mentioned above is Illustra-

years before Riis took up the writer's craft, the possibility of using pictures as effective tools in communication was an idea in its infancy when Riis began his crusade. The earliest Riis photographs had to be translated into drawings for the purpose of reproduction in any mass media. During the early decades of the twentieth century, photomechanical reproduction was perfected to a high level of craft, and by the advent of the FSA, periodicals that communicated primarily with pictures rather than words were born. The rapid flowering of the picture magazines was actually a flowering of the ideas Riis, Hine, and Stryker recognized decades before.

The full impact of the work of these three men has only recently been fully realized in a broad sense. *Charities and Commons,* which later became *Survey Graphic* during the teens and the twenties, recognized the potential of the work of this impressive triumvirate, but it appears that it was bound to the tradition of the word while making an effort to use the new language it had discovered. *Time, Life, Look, Fortune,* and *Coronet* carried the new medium to great pinnacles of enlightenment in the thirties and forties, and in the past decade a new generation has been looking at the works of MacLeish, Bourke-White, Rosskam and Wright, and at The Russell Sage Foundation and *The Making of an American* and essentially using these pioneer efforts at pictorial communication as models for the reform movements of today.

Captions

42 Workman perched on the edge of a beam, signaling to men below, Empire State Building, 1931. (IMP no. 2496)

43 Empire State Building, 1931. (IMP no. 9346)

DOROTHEA LANGE

44 Mills, New Mexico, 1935. (FSA [RA] no. 2816-E)

45 No title, Southern California, 1936 (see Illustration E). (FSA [RA] no. 9093-C)

46 Perryton, Texas, 1937. (FSA no. 18187-E)

47 Gas station, Kern County, California, 1937. (FSA no. 18401-E)

48 Plantation overseer and his field hands, Mississippi Delta, 1936. (FSA [RA] no. 8602)

WALKER EVANS

49 Bud Fields (see Illustration G). (FSA no. 8146-A)

50 Flood refugees in line waiting for food, Arkansas, n.d. (FSA [RA] no. 9231-M1)

51 Shop front, Vicksburg, Mississippi, 1936. (FSA [RA] no. 8072-A)

52 Minstrel poster in Alabama town, 1936. (FSA [RA] no. 1136-A)

ARTHUR ROTHSTEIN

53 Highway U.S. 30, Sweetwater County, Wyoming, 1940. (FSA no. 29598-D)

54 Hotel lobby, Colorado, n.d. (FSA no. 28840-D)

55 Hotel de Paris, Colorado, n.d. (FSA no. 28796-D)

56 Hymn singing at church meeting in Illinois, n.d. (FSA no. 26744-D)

MARION POST

57 Members of the Primitive Baptist Church in Moorehead, Kentucky, attending a baptizing by submersion, 1940. (FSA no. 55315-D)

CARL MYDANS

58 Mountaineers "spelling" themselves in front of store, Pikeville, Kentucky, 1935 (?). (FSA [RA] no. 524-M3).

59 Fair scene, Albany, Vermont, n.d. (FSA [RA] no. 778-M2)

BEN SHAHN

60 Watching the medicine show, Huntington, Tennessee, 1935. (FSA [RA] no. 6166-M4)

61 Rehabilitation clients, Boone County, Alabama, 1935 (See Illustration H). (FSA no. 6034-M2)

62 Arkansas, n.d. (FSA [RA] no. 6020-M5)

63 Child of strawberry picker, Louisiana, (FSA no. 6174-M3)

JACK DELANO

64 Mr. and Mrs. Andrew Lyman, Polish tobacco farmers near Winsor Locke, Connecticut, 1940. (FSA no. 41573)

65 Merritt Bundy, a miner and farmer who is a member of the TRI-County Coop Market at Dubois, 1940. (FSA no. 41294)

RUSSELL LEE

66 Cowboy drinking beer in beer parlor, Alpine, Texas, n.d. (FSA no. 12201-M3)

67 Fortune teller, state fair, Donaldsville, Louisiana, 1938. (FSA no. 11783-M5)

68 Sign, Morgan County, Louisiana, 1938. (FSA no. 11850-M2)

PALMER

69 Steel manufacture. Here is one of the men upon whom depends the success of our effort to produce for the boys in uniform. He is a steel mill maintenance man on his way to repair a breakdown. It's his job to see to it that nothing interferes with our war production. (OWI no. 1218-D)

GORDON PARKS

70 Capitol office worker, Washington, 1942. (FSA [OWI?] no. 13407-C)

PAUL CARTER

71 See Illustration J. (FSA [RA] no. 2841)

JOHN COLLIER

72 Grandfather Romero, Trampas, New Mexico, 1943. (FSA [OWI?] no. 17796-E)

JOHN VACHON

73 Church at Wounded Knee, South Dakota, 1940. (FSA no. 61741-D)
74 Ozark Mountain family, n.d. (FSA)
75 Homestead of wheat farmer in Ransom County, South Dakota, 1948. Typical of the FSA theme carried over to Stryker's direction of the Standard Oil of New Jersey Documentary Project. (SONJ no. 54606)

Picture Credits

All of the Riis photographs, except Illustration A, are from the Jacob A. Riis Collection of the Museum of the City of New York. Illustration A is from the Roy E. Stryker Collection at the University of Louisville Photographic Archives. The Lewis Hine photographs are all from the Lewis Hine Collection of the International Museum of Photography at George Eastman House. The FSA photographs and the single Standard Oil Company of New Jersey photograph are all from the Roy Stryker Collection of the University of Louisville Photographic Archives.

The numbers following each photograph are the identification numbers assigned to the pictures by the Museum of the City of New York for the Riis photographs. The Hine numbers are those assigned by the International Museum of Photography at George Eastman House, and the FSA, RA, or OWI numbers are those now in use for the negative file of the Library of Congress. These numbers are provided for the convenience of those wishing to acquire prints of these photographs.

It may be of interest to the contemporary photographer to note that the negative numbers for the FSA, RA, and OWI material provide some clue to the negative size used by the photographer. The A suffix is for 8" × 10", the D is for 4" × 5", the E is for 2¼" × 2¼", and the M indicates 35mm film negatives.

Unpublished material:

In the Photographic Archives of the University of Louisville, Louisville, Kentucky, there is a vast file of unpublished material in the Roy E. Stryker Collection. In the International Museum of Photography at George Eastman House in Rochester, New York, there is a large collection of Lewis Hine material.

Biography

In December 1972, Professor Robert J. Doherty, Jr. assumed the position of Director of the International Museum of Photography of George Eastman House in Rochester, New York. In 1951, Professor Doherty graduated as Bachelor of Fine Arts at the Rhode Island School of Design and he finished his education at Yale as Master of Fine Arts.

His career as designer, promoter, production manager, and director in different parts of American industry (printing business, aluminum industry, form shapes) brought him many honors and distinctions. In 1959, his work on "Aluminum Foil Design" was published.

His photographical work was first exhibited in Watertown, Connecticut, later in the Arts Club of Louisville, and recently at the Allen R. Hite Institute of the University of Louisville. In 1967, he became a director of the Photography Collection of the Hite Institute. He also published works about creative photography and the photography of the First World War. He organized and arranged several exhibitions at the Hite Institute about photography and graphic design of the nineteenth century, and in 1962, the exhibition "USA-FSA," which extensively demonstrated the performance and impact of the Farm Security Administration's photographic project.

Doubtless, Professor Doherty is the expert who best understands the subject of social-documentary photography in the USA. He also is the author of a book about Roy Stryker and the development of documentary photography of the FSA during the 1930's.

For 13 years, Professor Doherty was designer at the University of Louisville, before being called to Rochester. During this period and in addition to his academic teaching, he was interested in architecture and urban development—subjects he also treated in exhibitions and publications.

Professor Doherty was born in 1924, in Everett, Massachusetts. He is married and the father of three children.

Romeo E. Martinez

As editor of this series, Romeo E. Martinez crowns an almost 40-year career as journalist and picture director. Martinez was chief of the illustration departments with the magazines *Vu* and *Excelsior* in Paris and is a member of the *Conseil en illustrations* de la *"Grande Encyclopédie française."* His ten years as editor-in-chief of the monthly magazine *Camera* in Lucerne contributed greatly to the international success of this journal. He has been responsible for the organization of the biennial of photography in Venice.

Bibliography

1. Brown, Theodore M. *Margaret Bourke-White, Photojournalist.* Ithaca: Andrew Dickson White Museum, 1972.
2. Elliot, George P. *Dorothea Lange.* New York: Museum of Modern Art, 1966.
3. Gutman, Judith Mara. *Lewis Hine.* New York: Walker and Company, 1932.
4. Hine, Lewis W. *Men at Work.* New York: The MacMillan Company, 1932.
5. Hurley, Forest Jack. *Portrait of a Decade.* Baton Rouge: Louisiana State University, 1972.
6. Keller, Morton, ed. *The New Deal.* American Problem Studies. New York: Holt, Rinehart and Winston, 1963.
7. Markoff. *The Changing Years, 1904–1954.* New York: The National Child Labor Committee, 1954.
8. Mitchell, Broadus. *Depression Decade,* Economic History of the United States, Vol. IX. New York, Evanston, and London: Harper & Row, 1947.
9. Riis, Jacob A. *How the Other Half Lives.* New York, Dover, 1971.
10. Smith, Adolph. *Street Life in London.* Photographs by John Thompson. New York and London: Benjamin Blom, 1969.

Index